IMAGES
of America

GREEN-WOOD
CEMETERY

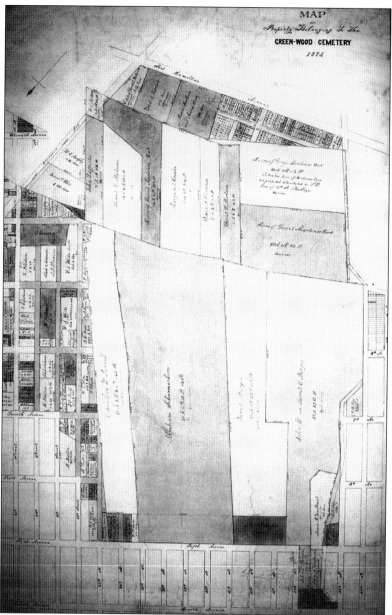

In its original form, this c. 1874 map was color tinted and showed the various owners of the property, which was acquired for Green-Wood. Originally Henry Evelyn Pierrepont and his group of investors purchased about 137 acres of mostly unused farmland to start Green-Wood. Over the years the cemetery acquired more property until it reached its current dimension of 478 acres. It is one of the largest green spaces in New York City. (Courtesy of the Green-Wood Historic Fund.)

On the cover: Taken around 1899, this photograph shows Green-Wood Cemetery's 25th Street entrance. The arched Gothic Revival gateway was designed by the firm of Richard Upjohn and Son and constructed between 1861 and 1863. To the right, behind the gentlemen standing on what is now Landscape Avenue, are graves. (Courtesy of the Green-Wood Historic Fund.)

IMAGES
of America

GREEN-WOOD
CEMETERY

Alexandra Kathryn Mosca

ARCADIA
PUBLISHING

Published by Arcadia Publishing
Charleston SC, Chicago IL, Portsmouth NH, San Francisco CA

Printed in the United States of America

Library of Congress Catalog Card Number: 2007941422

For all general information contact Arcadia Publishing at:
Telephone 843-853-2070
Fax 843-853-0044
E-mail sales@arcadiapublishing.com
For customer service and orders:
Toll-Free 1-888-313-2665

Visit us on the Internet at www.arcadiapublishing.com

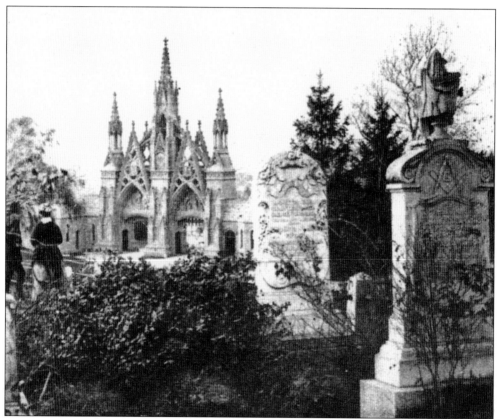

This early view of Green-Wood Cemetery in Brooklyn dates from the latter part of the 19th century. This book is dedicated to Anthony M. DeStefano, who is steeped in Brooklyn lore, and in memory of Peter Provenzano, who was Brooklyn born. (Courtesy of the Green-Wood Historic Fund.)

CONTENTS

ACKNOWLEDGMENTS

There were a number of people who assisted me in the preparation of this book, which grew out of my love and fascination for Green-Wood Cemetery. Foremost, I want to thank the excellent and peerless staff of Green-Wood who did so much to help me bring this work to fruition. In particular, I want to thank Eugene Adamo and Theresa LaBianca for their cheerful, tireless, and invaluable assistance. I also want to thank Jane Cuccurullo, Nicholas Pisano, Ken Taylor, and resident historian Jeffrey I. Richman. Special thanks are due to Richard J. Moylan, president of Green-Wood, for giving me support during the research and writing of this book. Richard's assistance proved essential and goes along with his untiring efforts to expand the public awareness and appreciation of such an important place in American history.

I also want to thank my friend and colleague Raymond J. Neufeld for sharing some of his excellent photographs that appear within these pages. I also am grateful for the assistance and knowledge of another longtime friend, history buff, and Brooklyn native, Gene Raymond Brenciforte.

Erin L. Vosgien, Arcadia's junior publisher, who saw the possibilities and promise of this book, deserves special mention. Her patience and diligence helped bring this book to completion.

Thanks also to Julie May of the Brooklyn Historical Society for being so accommodating.

Unless otherwise noted, images are from the author's collection. Archival articles from the *New York Times* and the *Brooklyn Eagle* were consulted for this book.

INTRODUCTION

In New York City, a place that hardly sleeps, Green-Wood Cemetery earns the honor as its top spot of perpetual rest.

Perched atop the highest point in Brooklyn and overlooking the distant New York Harbor, Green-Wood is one of the most famous urban cemeteries in America and the world. Within its 478 acres of gently rolling landscape are the graves of almost 600,000 people. The markers for the burials range from opulent stone and marble edifices built for eternity to small, simple stelae. Buried within its grounds are some of the most important people in the life of the nation, as well as those who lived their lives in decent obscurity as toiling citizens of a great city.

Green-Wood is the final resting place for people from all walks of life, some of whose lives were intertwined: politicians, inventors, soldiers, actors, sports figures, writers, artists, scientists, business leaders, and tycoons. From Green-Wood's earliest days, famous American names proliferated: DeWitt Clinton, the former governor of New York; politician and publisher Horace Greeley; Elias Howe, inventor of the sewing machine; Rev. Henry Ward Beecher; inventor Samuel Morse; industrialist Peter Cooper; and Henry Evelyn Pierrepont, the founder of Green-Wood.

It was through Pierrepont's efforts that Green-Wood came to be. Pierrepont, a member of one of Brooklyn's best-known families of the 19th century and a city planner, received the backing of other prominent Brooklyn residents, such as Peter Schermerhorn. As a result of Pierrepont's foresight, a hilly area of unused farmland that overlooked the area known as Gowanus was earmarked for the cemetery. Pierrepont and other investors purchased the cemetery land, which was laid out by David B. Douglass, who became Green-Wood's first president.

Pierrepont had been inspired by Mount Auburn Cemetery in Cambridge, Massachusetts. Until the emergence of cemeteries like Mount Auburn and Green-Wood, burials in America had largely taken place in churchyards. But in a city like New York, the sheer volume of interments needed for a growing metropolis strained the capacity of churches to handle these burials. As a result, the attraction of a rural site for a cemetery grew. Incorporated in 1838 as a nonprofit entity, Green-Wood soon recorded its first burial, that of Sarah Hanna.

The bucolic setting of Green-Wood turned the cemetery into a favorite place for outings. Green-Wood soon became a tourist attraction. Its reputation grew nationally, and at one point *Harper's Weekly* called Green-Wood "the largest and most beautiful burial place on the continent."

Harper's Weekly was not the only publication to extol Green-Wood. The *Brooklyn Eagle*, which took pride in covering the cemetery, said in 1878, "At all seasons of the year GW is more or less of a resort for the public. Its fame is world wide and visitors to this city do not think they have completed their round of objects of interest unless they have taken a drive or a walk through the green paths and among the white crested hills of the great cemetery."

As Green-Wood's fame grew, it was *the* place to be buried for many famous Americans. Historians believe that it was the decision of the family of DeWitt Clinton, the former governor of the state, to move his body from the site of his original interment in Albany to Green-Wood in 1853 that made the cemetery a fashionable place of repose.

The list of notables at Green-Wood reads like a who's who of America. Inventor Elmer Sperry; pharmaceutical titans Edward R. Squibb, Charles Pfizer, and William Colgate; lithographers Nathaniel Currier and James Ives; political leader William Magear "Boss" Tweed; Charles Higgins, inventor of india ink; the Kampfe brothers, inventors of the safety razor; Townsend Harris, founder of the City College of New York; and piano maker Henry Steinway are just a fraction of the famous names.

Green-Wood also serves as a resting place for many who served their country in military conflicts from the Revolutionary War to Iraq. More than 4,000 of those who served in the Civil War are buried at Green-Wood. Commemorating all those from New York who perished in that conflict is the refurbished Civil War Soldiers' Monument on Battle Hill.

In the decades after the Civil War, the nation continued on its march to industrialization and business development. Many of the innovators and so-called captains of industry amassed—and sometimes lost—what were great personal fortunes. They often chose Green-Wood as the place for their burial, erecting imposing family mausoleums. Among them were John Matthews (inventor of the commercial beverage carbonation process), John W. Mackay (Commercial Cable Company), Stephen Whitney (cotton and real estate), and Commodore Cornelius K. Garrison (railroads and commercial gas distribution).

Still others who made their mark in life and chose to be buried at Green-Wood are artists like Jean Michel Basquiat and Asher B. Durand; architects such as James Renwick Jr., who designed St. Patrick's Cathedral; William Surrey Hart, the famous cowboy actor of the silent film era; Florence LaBadie, a film actress from that same period; Walter Hunt, inventor of the safety pin; John Underwood of the iconic Underwood typewriter; inventor Steven D. Tucker; Charles "Mile-a-Minute" Murphy; and baseball legends Henry Chadwick and Charles Ebbets.

In keeping with the aspiration of making Green-Wood a preeminent cemetery, construction began in 1861 on the Gothic Revival arch at the main cemetery gate placed at Fifth Avenue and 25th Street. Designed by Richard Upjohn and Son, whose firm was active in the design of churches in Brooklyn, the arch has been described as breathtaking. Even in modern times, the ornate towers of the arch, soaring above the surrounding buildings and trees, give the appearance from a distance of an entrance to a magical city.

The idea of a city stuck with Green-Wood, as it became known as "the City of the Dead." But as the 19th century progressed, the architecture associated with Green-Wood stressed the romantic Victorian attitude toward death. A number of monuments that depict this highly embellished style of memorialization, some with majestic images of angels, are tied to the Victorian concept of resurrection and life everlasting. Those buried within the cemetery grounds may have left this world, but the architecture fostered the notion that the spirits of the departed were in a better place.

To be sure, along with the graves of the many famous and historic personages who populate the grounds, some of the most stunning and often whimsical monuments are to everyday citizens whose stories are no less compelling. As I walked the vast and sublime grounds, doing my research, I came across many surprises. Seemingly at every turn, there were monuments poignant in their simplicity and others magnificent in their grandeur that I had not noticed before.

Not content to be just a burial ground, Green-Wood's administration has taken major steps to connect to the lives of New Yorkers and tourists who visit the grounds. The cemetery has a rich and varied program of cultural events that draw people from all over the country. Today, under the direction of Green-Wood's president Richard J. Moylan, the cemetery has developed into one of the city's major cultural and historical attractions.

Green-Wood may be properly seen as a place of perpetual rest for the dead, but it is also a way for the living to connect with the past.

One

A PLACE OF REPOSE AND RECREATION

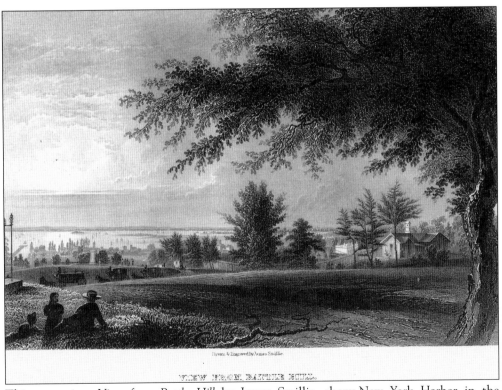

This engraving, *View from Battle Hill*, by James Smillie, shows New York Harbor in the background and depicts the area of Green-Wood well before any graves were placed. Note the figures in the lower left and carriages traversing the frame in the middle. (Courtesy of the Green-Wood Historic Fund.)

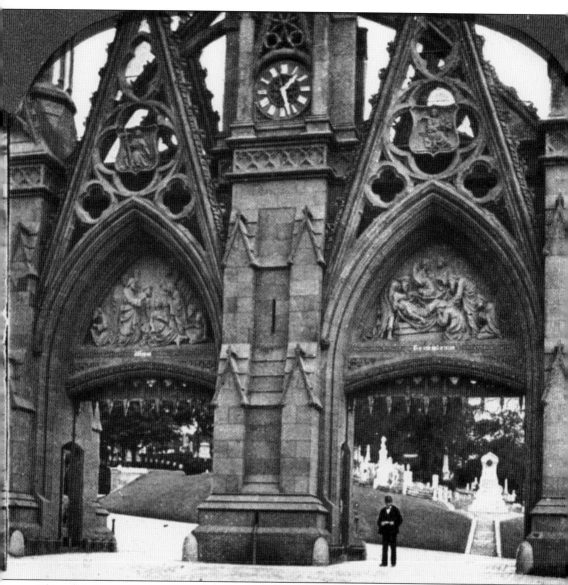

The magnificent Gothic Revival arch entrance to Green-Wood was constructed in the 1860s by the firm of Richard Upjohn and Son, the foremost designers of Brooklyn and New York City churches at that time. The arch is the emblematic symbol of the cemetery. Gracing the main entrance to Green-Wood, the arch is the most prominent structure in the cemetery and its 478 acres of what had once been farmland. Incorporated in 1838, Green-Wood is patterned on Mount Auburn Cemetery in Cambridge, Massachusetts, and was designed by David B. Douglass. In the early years, plots sold for under $100, and by 1860, Green-Wood recorded on average about 7,000 burials a year. By 2007, there were almost 600,000 burials within Green-Wood's grounds, which have a majestic view of Manhattan in the distance. (Courtesy of the Green-Wood Historic Fund.)

If there is anyone who could be considered the father of Green-Wood Cemetery, it is Henry Evelyn Pierrepont. The Pierrepont family is one of America's oldest families and played a significant role in early Brooklyn and New York City history. An urban planner, Pierrepont played a major role in devising the physical layout of the city of Brooklyn. Pierrepont is credited with developing the plan to set aside land for what is now Green-Wood. (Courtesy of the Brooklyn Historical Society.)

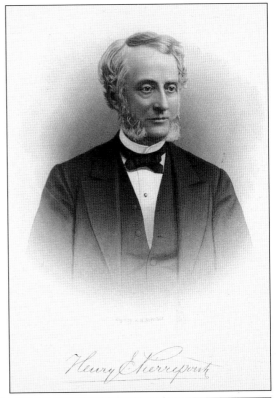

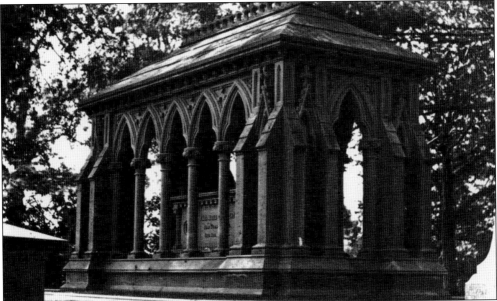

The Pierrepont family tomb was designed by Richard Upjohn, the same man who was responsible for creating the cemetery's massive Gothic Revival–style main entrance. The open-air church motif of the monument, obviously influenced by Upjohn's designing of churches, is in the Gothic Revival style and made of brownstone. At the time of his death, Pierrepont was president of the Green-Wood Corporation. (Courtesy of the Green-Wood Historic Fund.)

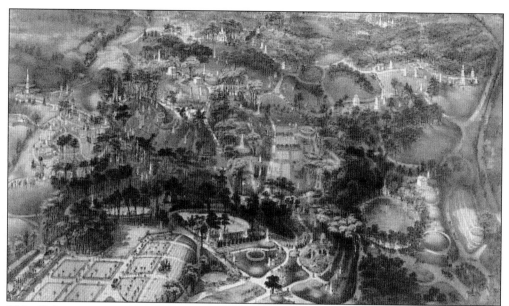

This 19th-century print, titled *Birds Eye View of Green-Wood*, was created by noted artist and lithographer John Bachmann. It shows a large expanse of the cemetery. The Swiss-born Bachmann became noted in the 19th century for these elevated views, drawn from an imaginary perspective above the earth. He also made numerous bird's-eye drawings of New York City, as well as Civil War battlefields. (Courtesy of the Library of Congress.)

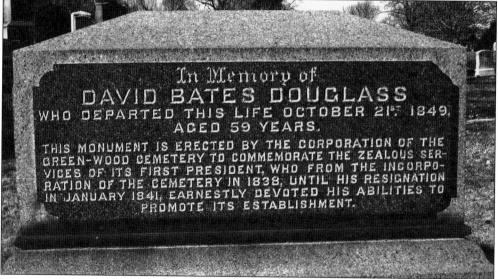

The original design of Green-Wood was created by David B. Douglass, who sculpted 178 acres of land. Douglass, the cemetery's first president, did not want to dramatically change the topography of the land. But he did recontour the natural slopes and where possible improved upon natural valleys. Lawns and trees were planted and a series of ponds manicured. Gateways, roadways, and footpaths proliferated and later became one of the attractions for the public. The paths were given names like Meadow Path and Evergreen Path. David B. Douglass died in 1849. His monument, dedicated by Green-Wood, extols his service to the cemetery and is located near Monarda Path.

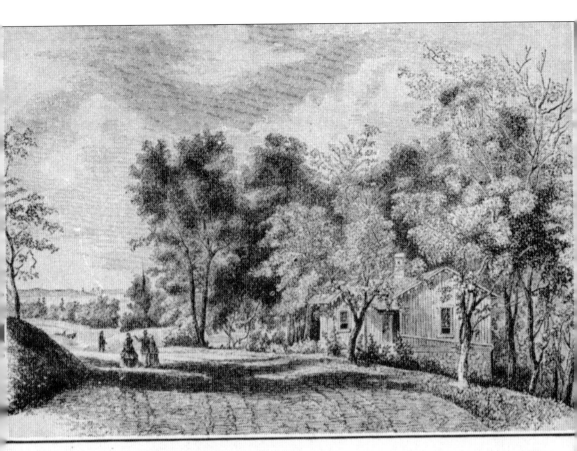

GARDENER'S LODGE (BATTLE HILL), GREENWOOD CEMETERY, IN 1840.

This 1840 engraving from the *Brooklyn Eagle* postcard series captures one of the earliest structures on the grounds, a wooden building known as the gardener's lodge. Little is known about this building, but it appears to have been a place for workers to store their equipment and perhaps even to have lived in. The gardener's lodge, which was situated on Battle Hill, is no longer in existence. (Courtesy of the Brooklyn Historical Society.)

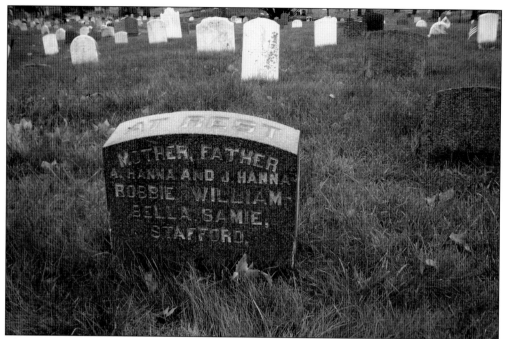

The name of Sarah Hanna is the first entry that appears in Green-Wood's ledger book. Hanna was buried on September 5, 1840, on the same day as three other relatives who had been transferred from the New York Marble Cemetery. Her first name is not etched upon the modest family stone.

No. 298514 THE GREEN-WOOD CEMETERY. July 6" 1898.
The remains of Duncan Phyfe.
were this day interred in Lot No. 2554 Grave No. 12,
Underiaker, C. J. Barr $7.00 paid.
Remarks, Superintendent of Interments,

This handwritten early interment order of noted 19th-century furniture maker Duncan Phyfe is dated July 6, 1898. At the time, a grave opening cost $7. The cause of death, entered on the back of the order, is given as senility. (Courtesy of the Green-Wood Historic Fund.)

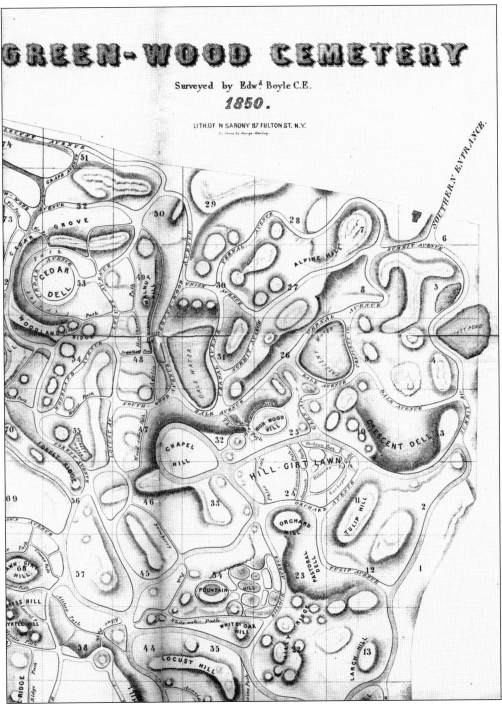

This *c.* 1850 map by famous photographer Napoleon Sarony, also a Green-Wood resident, shows part of the area encompassed by Green-Wood. It is situated on what is the highest natural land elevation in Brooklyn, overlooking the distant area of what became the Gowanus Canal. The neighborhoods surrounding Green-Wood evolved into Greenwood Heights, Borough Park, and Sunset Park. (Courtesy of the Green-Wood Historic Fund.)

15

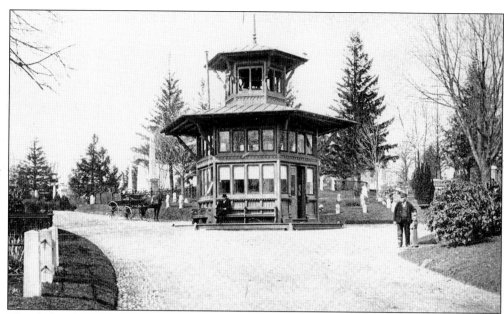

The shelter house contained a bell that was rung to signal cemetery employees when their workday began and ended. The bell also was used to signal the arrival of funerals so that cemetery staff could assemble at the individual burial sites. A communication link, perhaps a telegraph line, was used to communicate between the main office and the shelter house. The structure, which was located at the intersection of Southwood and Locust Avenues, was torn down in the late 1970s. (Courtesy of the Green-Wood Historic Fund.)

These Green-Wood maintenance workers or possibly grave diggers are seen in a photograph taken around 1870 posing with work tools. The 478-acre grounds of Green-Wood require a great deal of care. (Courtesy of the Green-Wood Historic Fund.)

This document is a receipt for the opening of a grave for a burial at Green-Wood in 1913. The charge for the grave opening was $11. (Courtesy of Joseph Redmond.)

THE GREEN-WOOD CEMETERY.

Persons having refreshments will not be admitted. Dogs will not be admitted. Smoking will not be allowed. Baskets and like articles, must be left in charge of the Porter. No Flowers or Shrubbery of any kind may be plucked. Any person disturbing the quiet and good order of the place by noise or other improper conduct will be compelled instantly to leave the Grounds.

C. M. PERRY,

COMPTROLLER.

Visitors are reminded that these Grounds are sacredly devoted to the interment of the DEAD. A strict observance of all that is proper in such a place will be required of all Visitors.

This lot owner's card was given to each family that purchased a grave site. The size of a business card, this green document lists some of the rules and regulations of Green-Wood. (Courtesy of Joseph Redmond.)

17

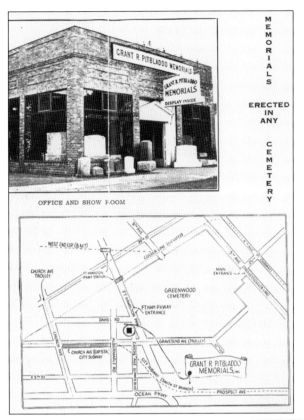

MEMORIALS ERECTED IN ANY CEMETERY

OFFICE AND SHOW ROOM

The name Pitbladdo was a well-known one in the monument trade. The Scottish family of stonecutters settled during the 19th century in Brooklyn, where William Pitbladdo started his shop outside the gates of Green-Wood in 1842. Thomas Pitbladdo followed in his father's footsteps and expanded the memorial art business, in which four generations played a role. Thomas was also the treasurer of the Brooklyn Tabernacle Church and was reported to be the last person to leave the building when it burned down in 1872. Thomas's son Grant, pictured here, expanded the company even further and had a shop at the eastern entrance to Green-Wood, also shown on this page, with a map showing its proximity to Green-Wood. Willard and Kenneth Pitbladdo were the fourth generation to carry on the family business. The Pitbladdo family is buried in Green-Wood. (Courtesy of the Pitbladdo family.)

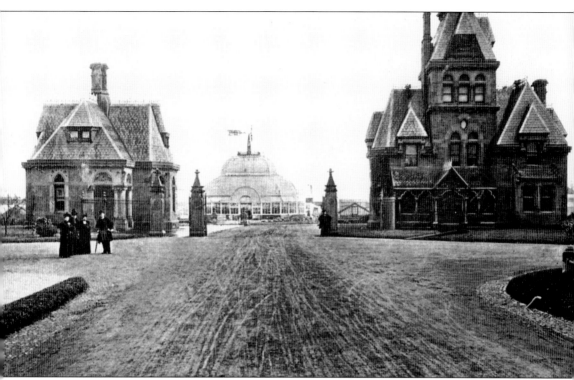

In the distance, seen between the structures at the eastern entrance to Green-Wood, is what is believed to be the Weir Florist greenhouse. James Weir was a well-known florist of the period who provided floral displays to Green-Wood. When he died in 1891 at the age of 84, the *Brooklyn Eagle* headline read wryly, "The Father of Floriculture in Brooklyn Cut Down." The business was continued by his sons James Jr., John R., and Frederick. Weir Florist participated in flower shows in the vicinity of Green-Wood, notably the chrysanthemum exhibition. The Weir family is buried in Green-Wood. (Courtesy of the Green-Wood Historic Fund.)

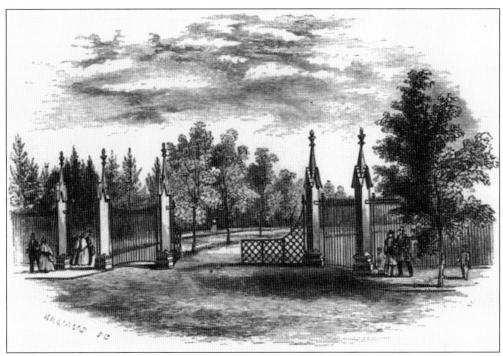

Green-Wood has several entrances that afford public access. The northern entrance gate, at Fifth Avenue, is depicted in this 19th-century etching.

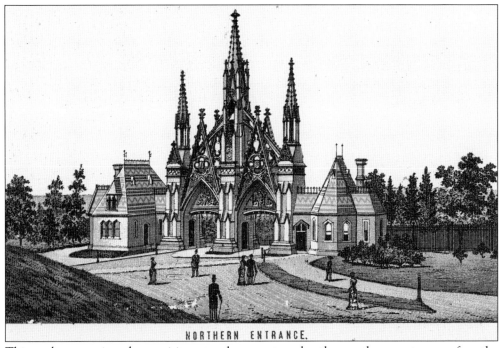

NORTHERN ENTRANCE.

This early engraving shows visitors to the cemetery by the northern entrance after the construction of the archway. Green-Wood's office is on the left. (Courtesy of the Green-Wood Historic Fund.)

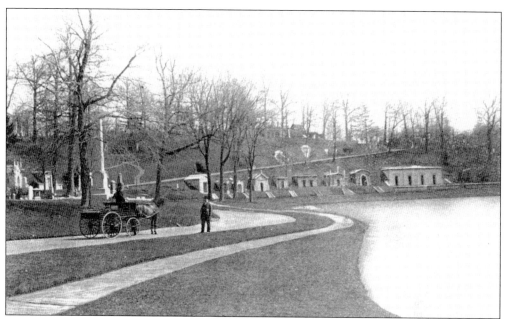

Four ponds currently dot the Green-Wood landscape. The largest body of water, pictured here, is known as Sylvan Water, followed by Valley Water, both of which are near the 25th Street entrance. Other bodies of water are named Crescent Water and Dell Water. As the photograph shows, the ponds add to the natural beauty of Green-Wood. (Courtesy of the Green-Wood Historic Fund.)

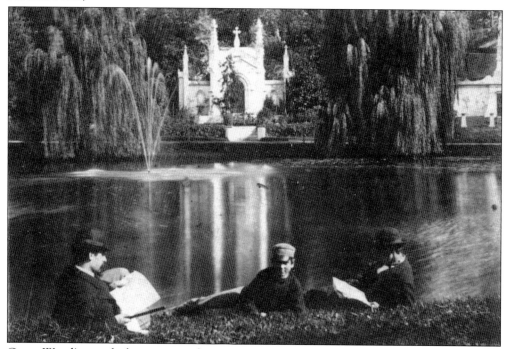

Green-Wood's ponds became another attraction for early visitors to the cemetery. This photograph shows people lounging by one of the serene bodies of water, which attracted aquatic fowl. (Courtesy of the Green-Wood Historic Fund.)

GREEN=WOOD
ILLUSTRATED
· 1891 ·

In 1891, Green-Wood offered a small bound volume named *Green-Wood Illustrated* of engravings depicting a number of the cemetery's popular memorials, which became tourist attractions. (Courtesy of the Green-Wood Historic Fund.)

GREEN~WOOD

CARRIAGE SERVICE

Carriages leave the stand inside of gate near the Northern Entrance, Fifth Avenue and Twenty-fifth Street.

The Drivers show and explain all the Monuments represented in this Album, and all the principal points of interest in the Cemetery.

——: FARE :——

ADULTS, - - - - - 25 CENTS EACH.
CHILDREN BETWEEN THE AGES OF FIVE AND TEN YRS., 10 " "

Lot owners wishing to alight at any part of the route, will be furnished

The last page of *Green-Wood Illustrated* offered information about Green-Wood's popular carriage tours of the late 19th century. (Courtesy of the Green-Wood Historic Fund.)

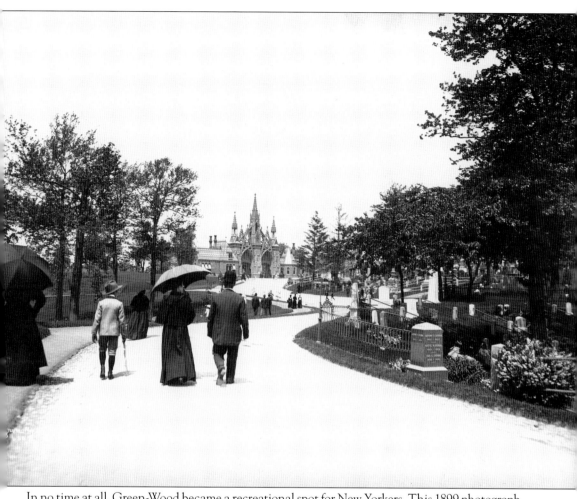

In no time at all, Green-Wood became a recreational spot for New Yorkers. This 1899 photograph shows visitors strolling through the cemetery grounds by the main entrance on Decoration Day, known today as Memorial Day. (Courtesy of the Museum of the City of New York.)

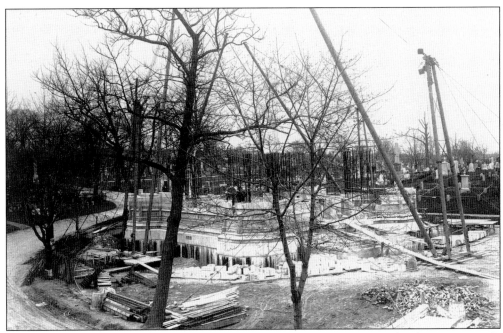

Built on the order of Tom Tower at Christ Church College, Oxford, England, Green-Wood's chapel was designed by the firm of Warren and Wetmore, which is responsible for the design of New York City's Grand Central Station and the Helmsley Building. Construction began in 1910 and was completed in 1911, on the former site of Arbor Water, one of the cemetery's original ponds. The finished structure of Indiana limestone occupies a spot not far from the 25th Street entrance near Valley Water. These photographs of the construction of the chapel were discovered by a New York City antiques dealer who gave them to Green-Wood. (Courtesy of the Green-Wood Historic Fund.)

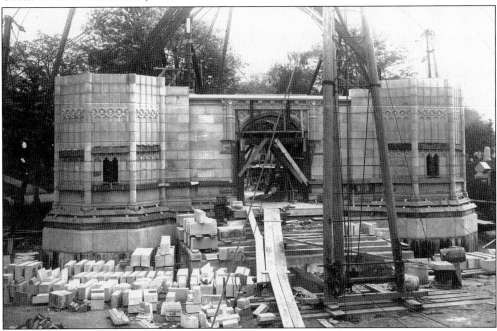

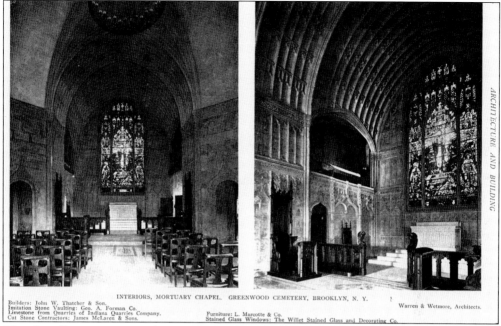

INTERIORS, MORTUARY CHAPEL, GREENWOOD CEMETERY, BROOKLYN, N. Y.

Builders: John W. Thatcher & Son.
Imitation Stone Vaulting: Geo. A. Forman Co.
Limestone from Quarries of Indiana Quarries Company.
Cut Stone Contractors: James McLaren & Sons.

Furniture: L. Marcotte & Co.
Stained Glass Windows: The Willet Stained Glass and Decorating Co.

Warren & Wetmore, Architects.

ARCHITECTURE AND BUILDING

The chapel's interior gives the impression of a small cathedral, with a stained-glass window that faces in a southerly direction and has the benefit of being lit by the sun. It is built on land that was once a pond known as Arbor Water. Although the chapel is used for funerals, it is also often filled with people for concerts, book discussions, lectures, and exhibits. (Courtesy of the Brooklyn Historical Society.)

In the 19th century, snow removal was unheard of in winter months so bodies were stored in special receiving vaults to await burial in the more temperate spring. These vaults (such as the one shown in the foreground) had the capacity to store hundreds of bodies. Several of the cemetery's hillside mausoleums can be seen in the background of this image, which appeared in *Green-Wood Illustrated*. (Courtesy of the Green-Wood Historic Fund.)

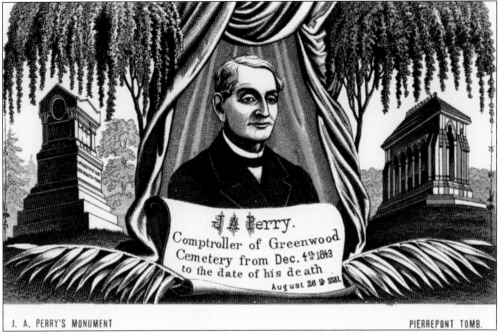

J. A. PERRY'S MONUMENT PIERREPONT TOMB.

Joseph A. Perry, the son-in-law of Henry Evelyn Pierrepont, managed Green-Wood for four decades. Under Perry's management, the cemetery more than doubled in size. This 19th-century postcard depicts Perry's monument on the left and Pierrepont's on the right. (Courtesy of the Brooklyn Historical Society.)

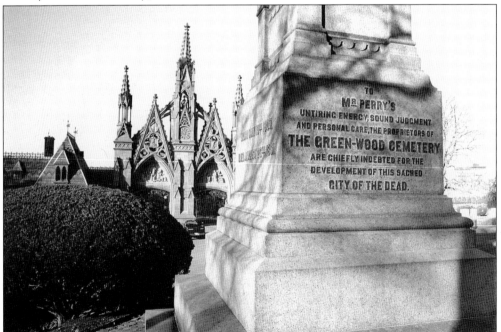

Perry's grave is in a prominent place within Green-Wood's main gate and is inscribed on both sides with words of gratitude for his years of service. This modern photograph is the rear view of Perry's monument, looking west.

Two

BROOKLYN PEOPLE, PLACES, AND POLITICS

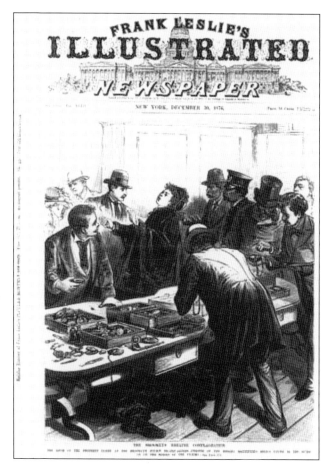

Until it merged with the other boroughs in 1898 to form the Greater New York City, Brooklyn was a separate city. It was a center of commerce, industry, and the arts. On December 5, 1876, Brooklyn was devastated by a theater fire that took almost 300 lives. The families had the grim task of viewing the personal effects of the dead for identification, as depicted on this newspaper cover. (Courtesy of the Library of Congress.)

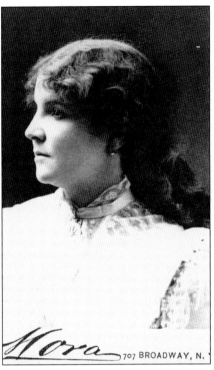

707 BROADWAY, N. Y

Popular stage actress Kate Claxton was performing the night of the Brooklyn Theatre fire and was among the survivors. In an eerie coincidence, less than a year later, a hotel in St. Louis, in which she was a guest, burned to the ground, causing journalists to caution that she was bad luck. Still she continued her role as Louise in *The Two Orphans*, the play featured at the time of the fire, until 1903. Claxton's death in 1924, at the age of 74, made headlines. She is buried at Green-Wood. (Courtesy of Bill Nelson.)

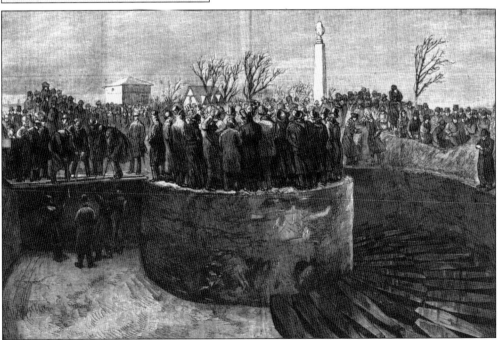

The dead of the Brooklyn Theatre fire were placed in a mass grave at Green-Wood, buried in a circular pattern. Those buried were victims whose families could not afford the cost of burial or who were burned beyond recognition. One hundred and three coffins were lowered into the grave, with their heads pointed toward the center. The funeral service took about two hours, and 42 grave diggers filled in the trench. (Courtesy of the Green-Wood Historic Fund.)

Eventually a granite obelisk was placed on the site commemorating the many lives lost in one of the worst fires in New York City's history. (Courtesy of the Green-Wood Historic Fund.)

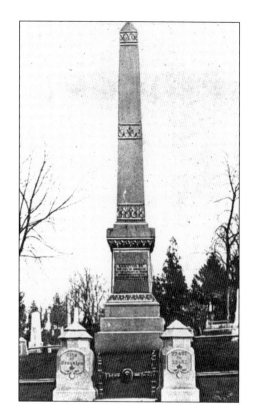

This etching shows visitors to Green-Wood paying respects at the obelisk erected for the Brooklyn Theatre fire victims. (Courtesy of the Green-Wood Historic Fund.)

Businessman and civic leader James S. T. Stranahan, known as the first citizen of Brooklyn, played instrumental roles in some major infrastructure projects in Brooklyn, including Eastern and Ocean Parkways. He also played a key role in uniting Brooklyn with New York City and was president of the Brooklyn Bridge Company, the entity that carried out the construction of that great bridge. Stranahan presided over the dedication of the Brooklyn Bridge in May 1883. But perhaps Stranahan's most ambitious project was the development of Prospect Park. As Brooklyn's parks commissioner, Stranahan oversaw Prospect Park's creation. On the way to Stranahan's 1898 burial in Green-Wood, the funeral procession went through Prospect Park in his honor. The bronze statue by Frederick MacMonnies shown below, commemorating Stranahan, stands at Grand Army Plaza, the entrance to the park. (Below, courtesy of the Brooklyn Public Library-Brooklyn Collection.)

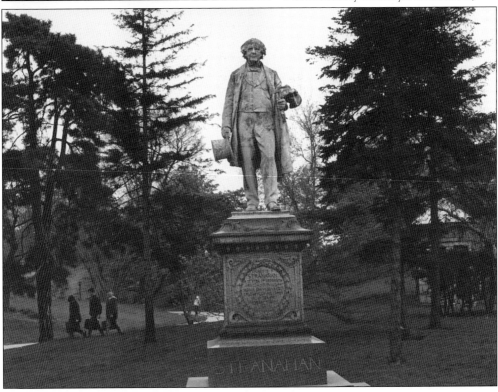

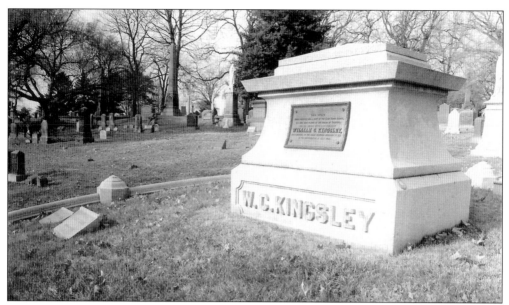

A wealthy Brooklyn businessman, William C. Kingsley was the contractor who orchestrated the construction of the Brooklyn Bridge connecting the boroughs of Brooklyn and Manhattan. He was closely aligned with political boss William Magear "Boss" Tweed. Among Kingsley's other accomplishments was his service as publisher of the *Brooklyn Eagle*, once the borough's major daily newspaper. Kingsley's monument bears a plaque that notes that the stone was formerly part of the East River Bridge, as the bridge was once known. Master planner Henry Cruse Murphy and engineer Col. Julius Walker Adams are also buried in Green-Wood.

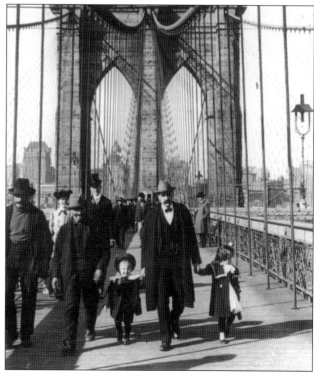

The Brooklyn Bridge was a massive undertaking. It was constructed by John and Washington Roebling at a cost of over $15 million. It opened in 1883 and has remained structurally sound, handling hundreds of thousands of vehicles a week and a high volume of pedestrian traffic. It is a major tourist attraction and one of the most photographed bridges in the world. (Courtesy of the Library of Congress.)

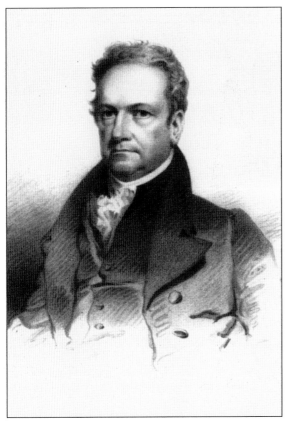

The grave of DeWitt Clinton, mayor of New York City and governor of New York State, became Green-Wood's first tourist attraction. Born in 1769 in Napanoch, Clinton went on to have a career of great success in public life and government. He is credited with having the foresight to push for the creation of the Erie Canal while he was governor of New York State. Clinton also at various times held other government jobs: U.S. senator, lieutenant governor of New York, and mayor of New York City. Clinton ran unsuccessfully for president in 1812 as the candidate of the Federalist Party. Originally interred at a cemetery near Albany when he died in 1828, Clinton was disinterred and reburied at Green-Wood in 1853 where he is memorialized with a large bronze statue sculpted by Henry Kirke Brown. (Left, courtesy of the Library of Congress; below, courtesy of the Green-Wood Historic Fund.)

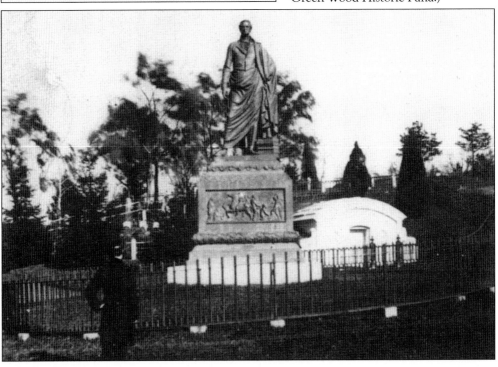

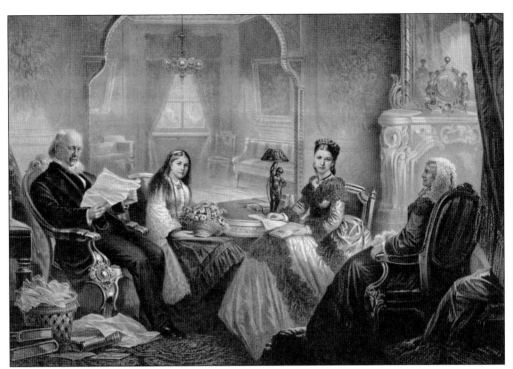

Horace Greeley was a self-made man who had an illustrious career as a newspaper publisher and politician. Greeley, who is widely attributed with having coined the phrase "Go West, young man," got into publishing in 1838. In 1841, he merged his newspaper operations into the *New York Tribune*, remaining its editor for the rest of his life. His newspaper became an unofficial voice of the Republican Party when the party was founded in 1854. Greeley died in 1872, soon after losing a bid for the presidency. Despite his wishes to the contrary, Greeley's funeral was befitting a statesman, attended by Pres. Ulysses S. Grant, Vice Pres. Schuyler Colfax, and many other dignitaries. Rev. Henry Ward Beecher assisted in the address. The *Brooklyn Eagle* noted that "the sons of poverty and the scions of wealth alike did silent homage to his virtues." (Above, courtesy of the Library of Congress; right, courtesy of the Green-Wood Historic Fund.)

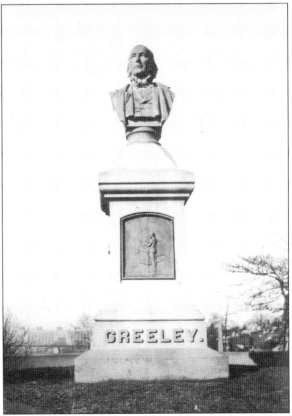

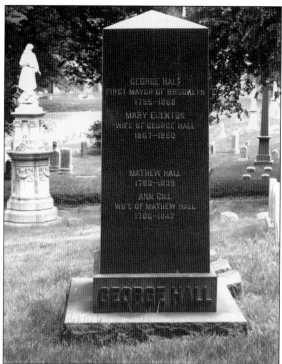

George Hall was the first mayor of the City of Brooklyn and was reelected in 1855. When Hall died in April 1868, his funeral was a huge event. Hall's body lay in repose inside his Livingston Street home at which Rev. Henry Ward Beecher gave the funeral oration. Outside, throngs lined both sides of Court Street from Montague to Schermerhorn Streets, hoping to take a last look at the mayor.

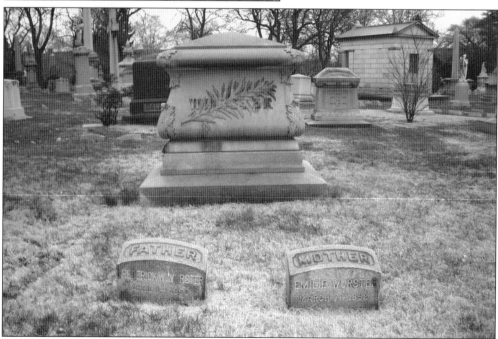

Brooklyn's last mayor before it became a part of New York City in 1898 was Frederick Wurster. Taking office in January 1896, at a time that the push to consolidate Brooklyn with the other cities, including Manhattan, grew in popularity, Wurster led the opposition to the plan, failing to gain any significant allies. Consolidation was approved by the state legislature in May 1897, and the final consolidation took place in 1898.

Frederick Schroeder served as Brooklyn's mayor from 1876 to 1877. During his mayoralty, Schroeder presided over the stringing of the first wire on the Brooklyn Bridge. His term as mayor also saw the opening of Ocean Parkway and the beginning of the construction of Brooklyn's first elevated railway. Schroeder died from a cold he caught 20 days earlier at his daughter Polly's burial in Green-Wood. Ironically, just a week before he died, Schroeder's doctors described his condition as favorable.

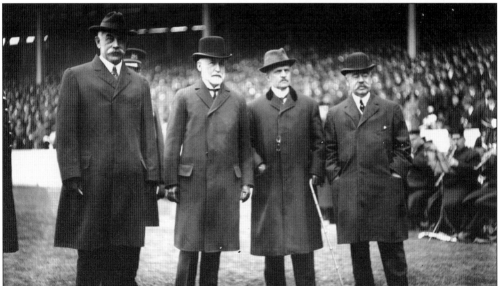

William Jay Gaynor, second from the left, holds the dubious distinction of being the only mayor of New York City to suffer an assassination attempt. Gaynor was shot after boarding a Europe-bound ship in August 1910 by a disgruntled city employee. Ironically, Gaynor died three years later aboard a ship. Gaynor's body lay in state in city hall. About 500,000 people lined up to watch the funeral procession from Manhattan over the Brooklyn Bridge to Green-Wood. (Courtesy of the Library of Congress.)

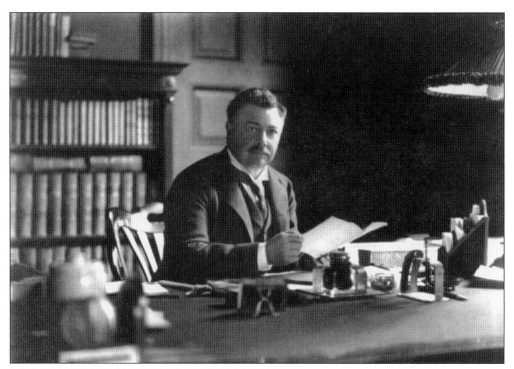

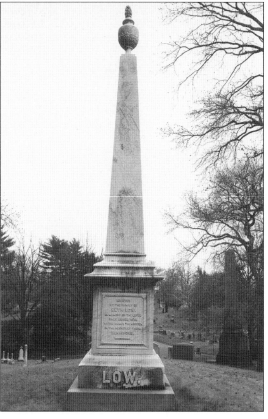

Seth Low served as mayor of Brooklyn from 1882 to 1885 at a time when Brooklyn was the third-largest city in the United States. During his tenure, Low officiated at the opening ceremonies for the Brooklyn Bridge. In 1901, Low was again elected as mayor, but this time for the newly consolidated New York City. Low also served as Columbia University's 11th president. A plaque at his grave site makes note of this. Low left the bulk of his large estate to his widow, with the remainder divided among numerous religious and educational institutions, including Columbia University and Tuskegee Institute. A number of close friends and family members, including his nephew and namesake Seth Low Pierrepont, grandson of Henry Evelyn Pierrepont, were also provided for. (Above, courtesy of the Library of Congress.)

An industrialist and politician, Abram S. Hewitt married Peter Cooper's daughter, Sarah, and went into the iron business with Cooper's son, Edward. This one-time mayor of New York City also served as chairman of the Democratic National Committee, as well as serving in Congress from 1874 to 1886. He later became a trustee of Columbia University. Hewitt is buried in the Peter Cooper family plot. (Courtesy of the Library of Congress.)

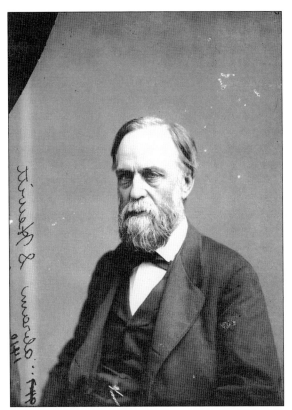

The next-to-last mayor of Brooklyn, Republican Charles Schieren, died from pneumonia in March 1915. Unknown to him, his wife, Mary Louise, was also dying from pneumonia in another room in their house. Within a day she was also dead, and they were buried in a double funeral. Their Angel of Death monument sculpted by Solon Borglum is inscribed with the words "In their lives they were lovely and in their death they were not divided." (Courtesy of the Green-Wood Historic Fund.)

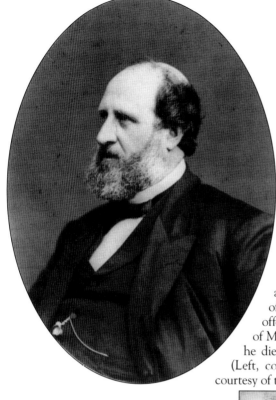

The infamous William Magear "Boss" Tweed served as New York state senator and Democratic county chairman. His name has become synonymous with Tammany Hall (Democratic Party political machine) corruption. When he died in jail, there was some controversy as to whether he could be buried at Green-Wood because of a cemetery rule that said "no person shall be interred therein who shall have died in any prison or shall have been executed for any crime." Joseph A. Perry, a Green-Wood official, told the *Brooklyn Eagle*, "We shall offer no opposition whatever to the interment of Mr. Tweed's remains in Green-wood" because he died in a debtors' prison, which was exempt. (Left, courtesy of the Library of Congress; below, courtesy of the Green-Wood Historic Fund.)

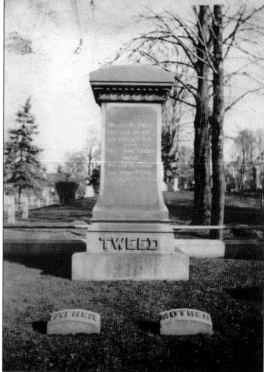

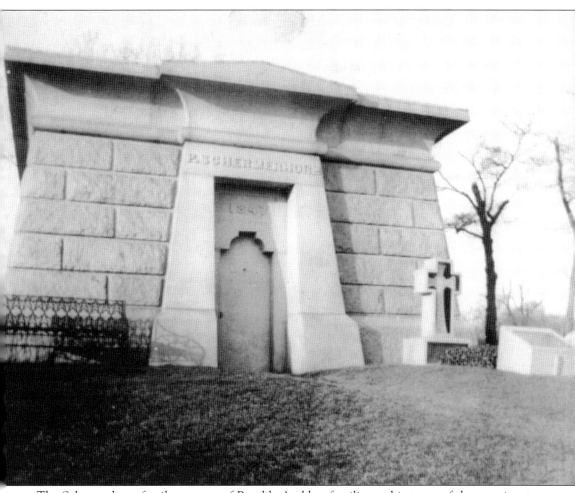

The Schermerhorn family was one of Brooklyn's oldest families and just one of the prominent Brooklyn families that elected to have Green-Wood as a final resting place. The family name is among the other distinguished names—Pierrepont, Clinton, Cortelyou, Middagh, Livingston, Montague, Luquer, and Sackett—of Brooklyn families, many of which are buried on the grounds. The land upon which this imposing mausoleum is built was once farmland, owned by the Schermerhorn family. These family names are also immortalized as streets in Brooklyn. The cast-iron bench on the left in this vintage photograph has been replaced by a tombstone. (Courtesy of the Green-Wood Historic Fund.)

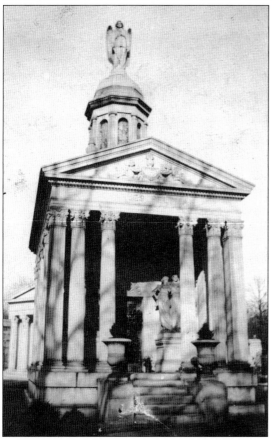

In 1867, German butcher Charles Feltman invented the hot dog—a homespun recipe that involved putting a boiled sausage on a bun. His invention preceded his opening a restaurant in Brooklyn's Coney Island in 1871 that became known as the Feltman Restaurant and Beer Garden. The restaurant land later became the site of Coney Island's Astroland. When he died in 1910, Feltman's estate was valued at more than $1 million, a substantial sum in those days and more than enough to afford his grand mausoleum. As shown in the food vendor photograph, the hot dog became a major fast-food item for the hordes of tourists who visited Coney Island. (Above, courtesy of the Library of Congress; left, courtesy of the Green-Wood Historic Fund.)

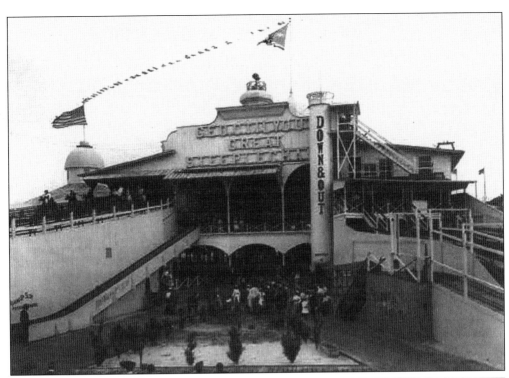

George Tilyou founded Coney Island's world-famous Steeplechase Park in 1897—an amalgamation of his rides, including the Wonder Wheel. Once the world's tallest Ferris wheel, the Wonder Wheel, which became an official New York City landmark in 1989, still operates today. In 1907, Steeplechase Park nearly burned to the ground as a result of a fire sparked by a cigarette ash. Tilyou rebuilt his park, which remained popular until its closing on September 20, 1964. Tilyou once quipped, "If Paris is France, Coney Island between June and September, is the world." An inscription below Tilyou's name on his monument reads, "Many Hopes Are Buried Here." (Above, courtesy of the Library of Congress; right, courtesy of the Green-Wood Historic Fund.)

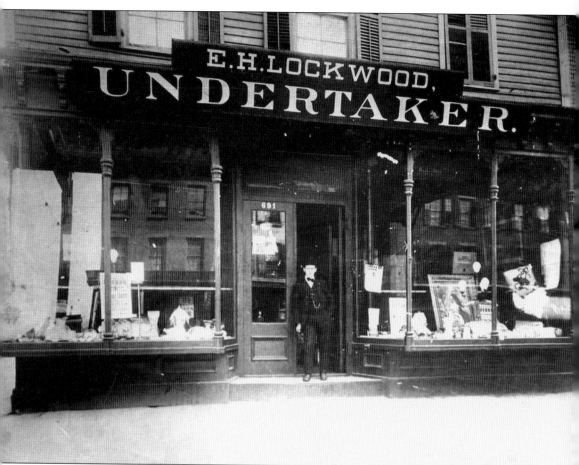

With death ever present, many funeral homes set up shop in the vicinity of Green-Wood as funerals moved from the house. This *c.* 1908 photograph is of Edward H. Lockwood, founder of the Lockwood Funeral Home, standing in the door of his funeral home on 21st Street in Brooklyn. The funeral home has been in business since 1880, always close to Green-Wood. Today the business is run by Gerard Lockwood, grandson of the founder. Seen in the windows are items to be donated to a church bazaar at Brooklyn's Our Lady of Perpetual Help. (Courtesy of Lockwood Funeral Home.)

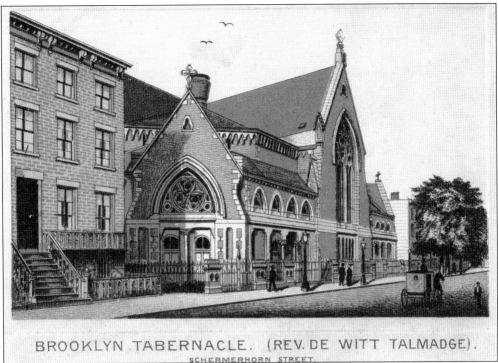

BROOKLYN TABERNACLE. (REV. DE WITT TALMADGE).
SCHERMERHORN STREET.

Charismatic Presbyterian preacher Dr. T. DeWitt Talmage was pastor of the Brooklyn Tabernacle Church, which burned down and was rebuilt on three occasions. When Talmage died in Washington, D.C., in April 1902, religious services were held in the nation's capital for him. Among the many floral displays adorning his casket were those from Pres. Theodore Roosevelt and First Lady Edith Roosevelt. One of the officiating pastors declared Talmage "one of the greatest clergymen of the century." (Above, courtesy of the Brooklyn Historical Society; below, courtesy of the Green-Wood Historic Fund.)

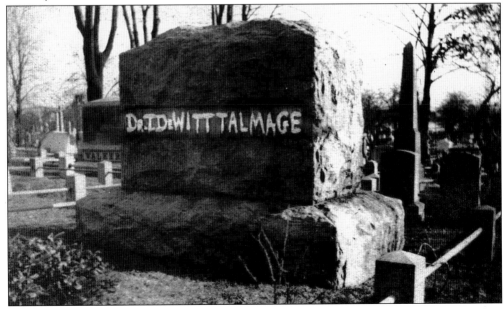

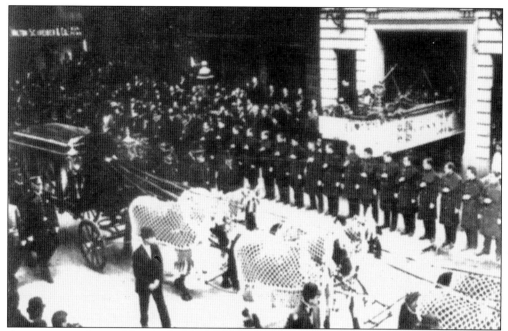

A common sight on New York City streets during funerals was the horse-drawn carriage. Here Brooklyn's first Italian undertaker, Frank Sessa, whose business opened in 1883, leads a procession through the streets of lower Manhattan for the funeral of a New York City detective. (Courtesy of Guido Funeral Home.)

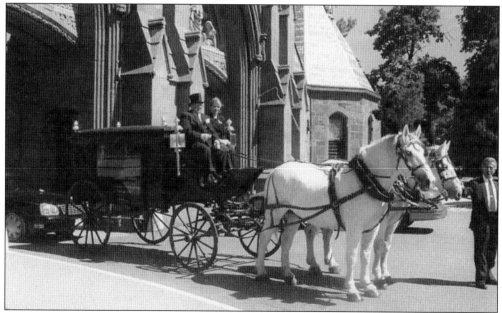

Today great-grandson Frank Guido and his daughter, Maria-Ray, carry on the horse and carriage tradition. Their Guido Funeral Home, located in a national landmark building, the John Rankin House, uses the 1888 Studebaker carriage upon request. In this modern photograph, Guido and his daughter are seated on the carriage coming through the main gate of Green-Wood. (Courtesy of Guido Funeral Home.)

Three

GREEN-WOOD AND THE CIVIL WAR

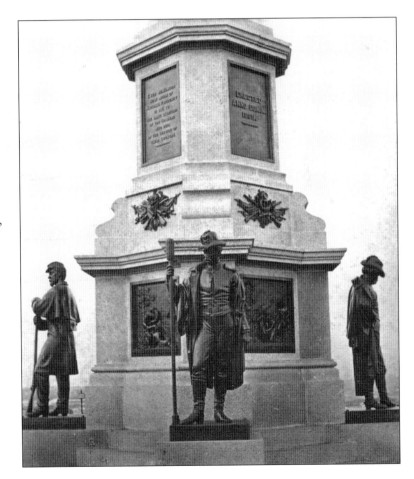

Erected in 1869, four years after the war's end, the Civil War Soldiers' Monument stands 35 feet high and is dedicated to the 148,000 New York soldiers who enlisted to serve in the Civil War. It was erected on a spot near Battle Avenue, facing west with a not so distant view of Manhattan. (Courtesy of the Green-Wood Historic Fund.)

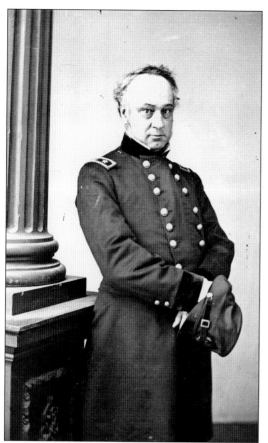

A West Point graduate, Maj. Gen. Henry W. Halleck, known as "Old Brains" for his intellect, was chief of all U.S. armies during the Civil War. A close associate of Pres. Abraham Lincoln, Halleck was at the president's bedside when he died, serving as a pallbearer at Lincoln's funeral. Halleck died in battle and is remembered through a street named for him in San Francisco and a statue in Golden Gate Park. (Courtesy of the Library of Congress.)

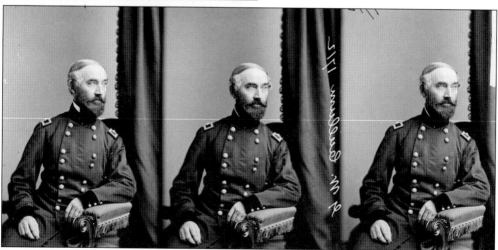

Gen. George Washington Cullum, another West Point graduate, rose quickly through the army ranks. In August 1861, he was promoted to brigadier general, working under Halleck, with whom he developed a close friendship. During Cullum's tenure as superintendent of the U.S. Military Academy from 1864 to 1866, admission standards were raised and discipline strictly enforced. Cullum's will bequeathed $250,000 to West Point to construct a memorial hall, which was named for him. (Courtesy of the Library of Congress.)

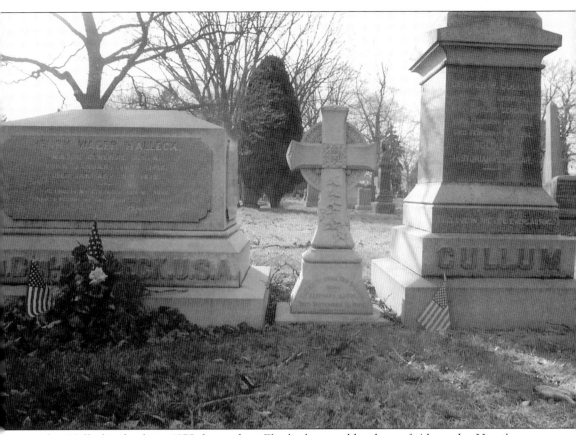

After Halleck's death in 1875, his widow, Elizabeth, granddaughter of Alexander Hamilton, married Gen. George Washington Cullum, her late husband's close friend. She is buried between both men, as shown in this photograph.

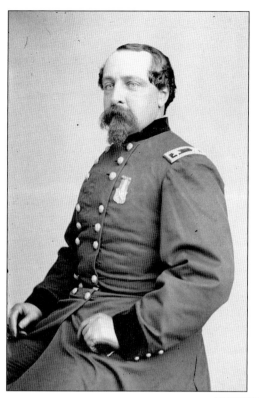

Born in Spain of Italian parents, Brig. Gen. Edward Ferrero took over the operation of his father's New York City dance academy, becoming renowned as one of America's leading experts in dance. Ferrero became a lieutenant colonel in the Union army and used his dancing skills to help his soldiers do precision military drills. Ferrero commanded troops in the siege of Petersburg and served through the Appomattox campaign. After the military, he continued to teach dance in New York City. Ferrero remained a dance instructor until retiring in May 1899, a few months before he died. Ferrero wrote a book about dance that is still available today. (Courtesy of the Library of Congress.)

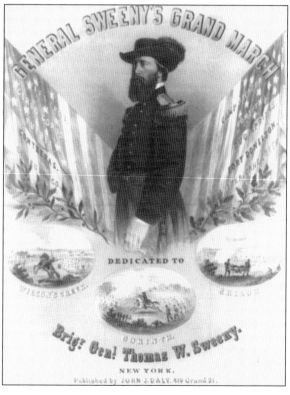

Wounded many times in battle, Gen. Thomas Sweeny, known as "Fightin' Tom," was a formidable leader. In the Civil War, Sweeny commanded troops in Missouri and in Georgia. At the battle of Atlanta, Sweeny got into a fistfight with another officer but was acquitted of charges in a court martial. After retiring, Sweeny lived in Astoria, Queens, until he died in 1892 at 72 years of age. A museum in his honor is based in Missouri. (Courtesy of the Library of Congress.)

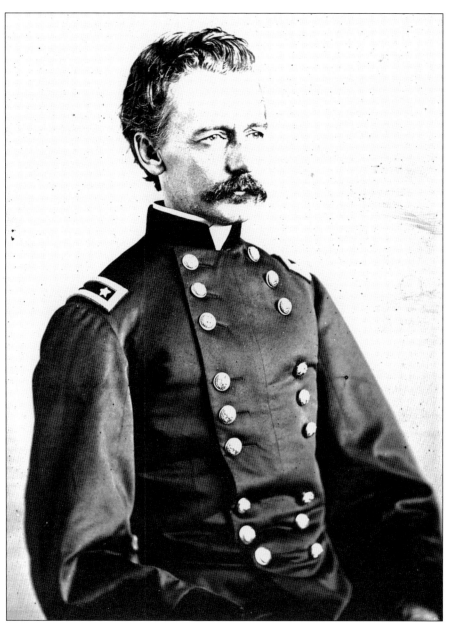

Despite being wounded in the First Battle of Bull Run, Maj. Gen. Henry Slocum went on to command troops in the Second Battle of Bull Run. After the war, Slocum returned to Brooklyn and represented New York in the House of Representatives. When Slocum died in 1894, thousands of Brooklynites mourned, affixing emblems of sorrow on buildings. At his funeral, Brooklyn's Protestant Episcopal Church of the Messiah was crammed with mourners, including Brooklyn mayor Charles Schieren. After church, the funeral procession passed through streets lined with spectators. A caisson brought Slocum's body to Green-Wood where thousands congregated. The *New York Times* noted that the "Green-Wood Bell tolled mournfully as the procession entered the cemetery." Three salvos were later fired in salute. The steamboat *General Slocum* was named in his honor, but it was destroyed with the loss of over 1,000 passengers during a terrible fire in 1904. (Courtesy of the Library of Congress.)

Thomas Dakin was both a baseball player and Civil War officer. He entered the Union side as a captain with the 13th Regiment of Brooklyn in 1862 and after the war briefly played for the Excelsior Club. He continued in military service and attained the rank of major general in the state militia. He had a reputation as a fast pitcher and was ranked as one of the top pitchers of the time. His monument was a major tourist attraction at Green-Wood in the 19th century. (Courtesy of the Green-Wood Historic Fund.)

Twenty-two-year-old William Moir Smith, a member of the New York State Militia, was wounded in the First Battle of Bull Run in July 1861. Smith later died in Richmond, Virginia, from the wounds he received in combat. Smith's ornate monument is adorned with the representation of a soldier's cap, bayonet, coat, and pack. (Courtesy of the Green-Wood Historic Fund.)

Col. Abraham S. Vosburgh was a leader of the 71st New York State National Guard Regiment. In 1861, the unit was sent to defend Washington, D.C., from possible attack by the Confederacy, but Vosburgh died shortly after being dispatched of noncombat causes. The members of his regiment commissioned sculptor Patrizio Piatti, who is also buried at Green-Wood, to design a monument in his honor. The imposing obelisk became a site for pilgrimages after the war for members of the regiment. (Courtesy of the Green-Wood Historic Fund.)

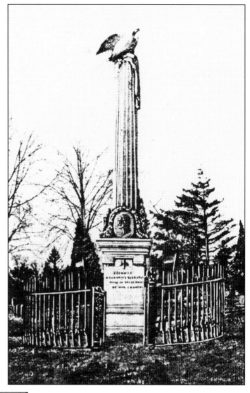

Gen. John B. Woodward served as a colonel with the 13th Regiment during the Civil War. After the war, Woodward served on various boards in Brooklyn, among them as president of Brooklyn's board of public works, parks commissioner, bank vice president, and a trustee of Brooklyn Institute of Arts and Sciences. Woodward died in 1896 from pneumonia at his home on Henry Street. He was deemed a man of such public importance that after his death flags were flown at half-mast on all public buildings in Brooklyn.

Born on a Virginia plantation, Robert Selden Garnett was the first general killed in the Civil War. He died while serving under Gen. Robert E. Lee in 1861. A Union soldier recovered his body from the battlefield, and Garnett was buried in a Baltimore cemetery. After the war, Garnett's remains were exhumed and interred in Green-Wood, along with his wife and infant child. His obelisk makes no mention of his first name or his service with the Confederacy.

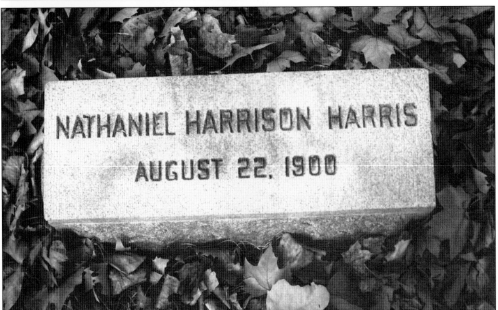

Mississippi-born Nathaniel Harris practiced law in Vicksburg until he was pressed into service for the Confederacy during the Civil War. In January 1864, Harris was made a general and led troops into battle in Spotsylvania and the battle of Seven Pines. When the war ended, Harris returned to his law practice in Vicksburg. Harris, who never married, died in August 1900 in England and was cremated. His ashes are buried at Green-Wood.

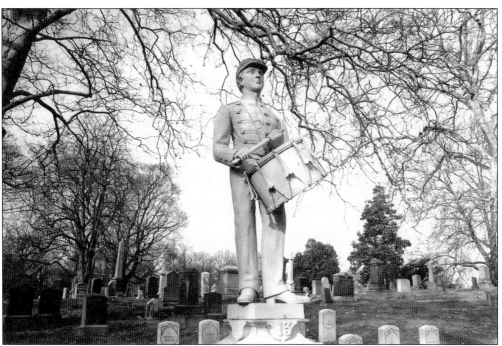

Twelve-year-old Clarence Mackenzie signed on with the 13th Regiment of the New York State Militia during the Civil War as a drummer boy, like others shown here, whose duty was to beat out march cadence. When the regiment left Brooklyn in 1861, Mackenzie accompanied the unit to a camp in Annapolis. Unfortunately, he was struck dead on June 11, 1861, by an accidental discharge of a musket during a training exercise and sadly, at the age of 13, became the first Brooklyn casualty of the war. Some 3,000 attended his funeral at Green-Wood. For a time Mackenzie's grave was marked only by a wooden sign. But after his story became part of a book about the cemetery, a campaign commenced that resulted in Mackenzie's grave being moved to a different spot marked by a zinc statue of a drummer boy. (Right, courtesy of the Library of Congress.)

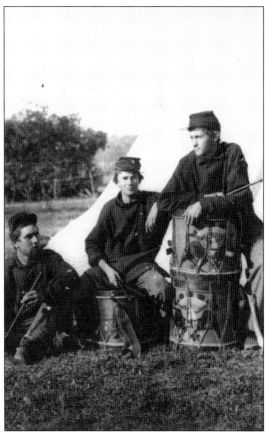

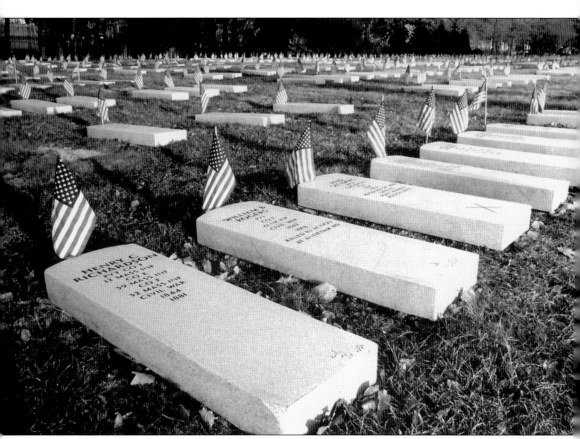

The Green-Wood Historic Fund's Civil War Project continues to locate, identify, and mark the graves of previously unidentified Civil War dead. To date, 4,000 veterans have been identified. The project has received 1,300 gravestones or bronze plaques from the Veterans Administration, so far, to designate previously unmarked graves. The newer markers will also be used to replace gravestones that have become weathered with age. Green-Wood has noted that the project, begun in 2002, has lasted longer than the Civil War itself. This photograph shows the new markers arrayed in a temporary display area near the cemetery's main entrance.

Four

ENTREPRENEURS AND HOUSEHOLD NAMES

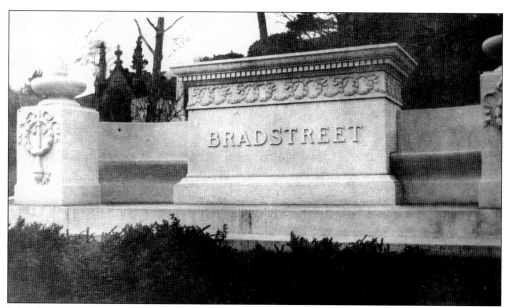

John Bradstreet was a lawyer from Cincinnati, Ohio, who in 1849 formed the Bradstreet Company, a credit company. Bradstreet moved his company to New York in 1855 and made a success of the business, rivaling many competitors. After Bradstreet died in 1863, his son Henry took over the business and incorporated it under the name the Bradstreet Company. In 1933, the firm merged with competitor R. G. Dun and Company. (Courtesy of the Green-Wood Historic Fund.)

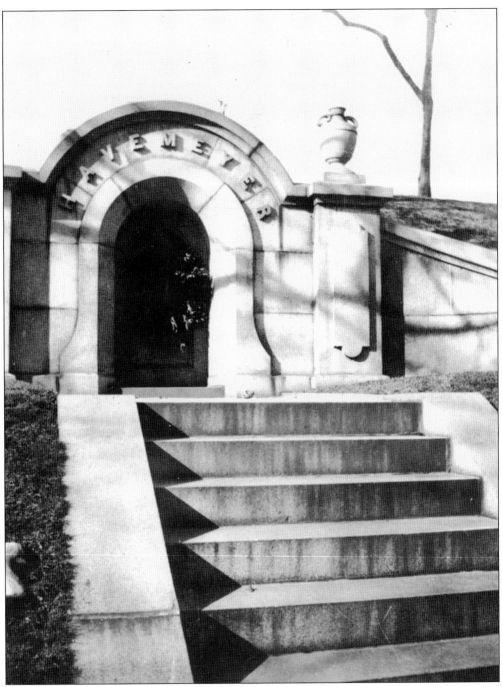

Henry O. Havemeyer became known as the "Sugar King" after the family business, the American Sugar Refining Company, became one of the most powerful in that industry. The business was attacked by regulators as being part of the monopolistic "Sugar Trust," and Havemeyer was considered a robber baron. In 1900, the company became known as Domino Sugar. Havemeyer died in 1897 at the age of 60, reportedly from acute indigestion, though the official cause was nephritis. (Courtesy of the Green-Wood Historic Fund.)

Charles Ebbets worked his way up from a job as a bookkeeper to president of the Brooklyn Dodgers. Ebbets, one of the best-known names in baseball history, died in 1925 at the age of 65 and was buried on a chilly day. The team's co-owner, Edward McKeever, caught a cold at the funeral and died 11 days later. Ebbets was the namesake of storied Ebbets Fields in Brooklyn. (Courtesy of the Library of Congress.)

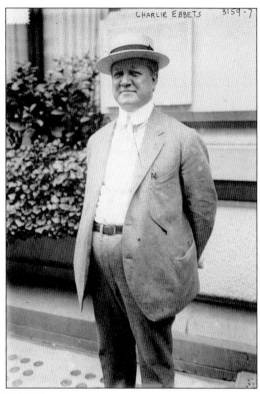

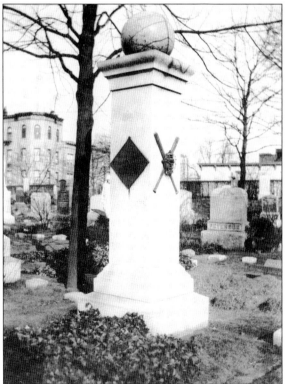

Henry Chadwick, who was known as "the father of baseball," died in 1908, at the age 83. Chadwick devised a method for scoring games, coined such terms as double play, goose egg, and single, and pioneered the use of statistics to judge a player's performance. He also was a sportswriter for the *Brooklyn Eagle* and the *New York Times*. His baseball-themed monument was crafted by Grant Pitbladdo, an accomplished Brooklyn monument craftsman. Chadwick was elected, posthumously, to the National Baseball Hall of Fame in Cooperstown in 1938. (Courtesy of the Green-Wood Historic Fund.)

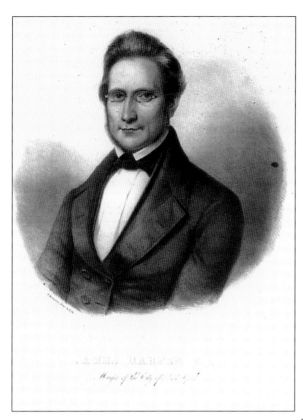

An admirer of Ben Franklin, James Harper began a printing business with his brother that later expanded to include publishing. Two other brothers were brought into the firm named Harper Brothers, known today as HarperCollins. Harper also served as a Republican mayor of New York City. This photograph is his official 1844 mayoral portrait. (Courtesy of the Library of Congress.)

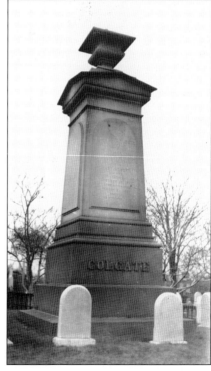

William Colgate's father was a partner in the manufacturing of soap and candles. Colgate helped in the business, but the partnership dissolved, and his father returned to farming. Colgate later revived the business, and in 1806, it became known as Colgate and Company. Later Colgate-Palmolive became a household name in toothpaste, toiletries, soap, and other household products. Colgate, a founder of Colgate University, died in March 1857 at the age of 74. (Courtesy of the Green-Wood Historic Fund.)

In 1818, Henry Sands Brooks founded H. and D. H. Brooks and Company. In 1870, his sons inherited the family business and gave the company its current name, Brooks Brothers. The company's suits and clothing became a favorite of Theodore Roosevelt, Ulysses S. Grant, and Abraham Lincoln. In fact, Lincoln was wearing a black custom-made frock coat the night he died. The mission to provide high-quality clothing to fashionable men has earned Brooks Brothers the distinction of being America's oldest men's store.

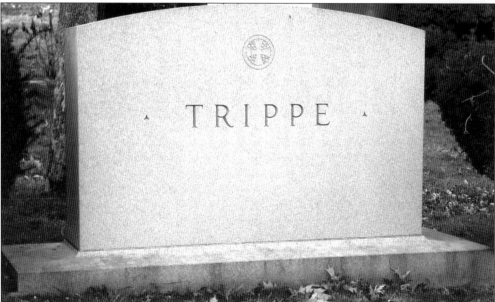

Yale graduate Juan Trippe founded Pan American World Airways at the age of 28. Trippe got his first aviation experience when he bought seven surplus navy training planes for $500 each and with friends shuttled passengers for $5 a ride from Coney Island to Long Island beaches. Using Cuba as a base, Trippe developed an aviation business in the Caribbean, where he acquired a small airline that became Pan American World Airways. Trippe was posthumously awarded the Medal of Freedom in 1985.

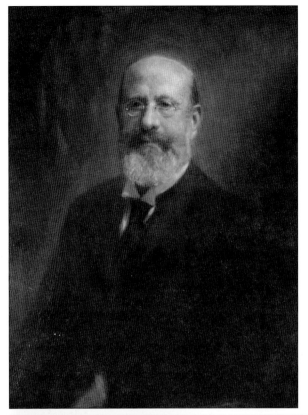

The storied Fifth Avenue toy store in New York City, FAO Schwarz, was founded in 1870 by German immigrant Frederick August Otto Schwarz. Schwarz originally worked at a Baltimore stationer when he came up with the idea to showcase toys in the store window. The toys began to outsell the stationery. So, in 1862, Schwarz and his three brothers went into the toy business, naming it Toy Bazaar. The family expanded the retail toy business to Philadelphia and Boston. In 1870, Schwarz moved his business to New York City, renaming it FAO Schwarz. The business at one time had 40 locations, and its flagship store on Manhattan's Fifth Avenue continues to be a famous tourist attraction. Although he was a giant of the toy industry, his monument is a modest stone, which belies his stature. (Left, courtesy of FAO Schwarz Inc.)

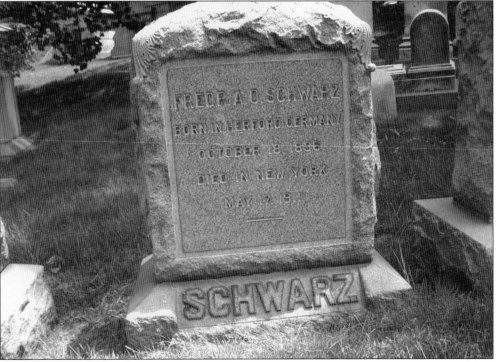

Leonard W. Jerome, a sportsman, had a passion for Thoroughbred horses. Jerome was one of the founders of the American Jockey Club and a moving force in the construction, along with August Belmont Sr., of the Jerome Park Racetrack in the Bronx, where the Belmont Stakes was first held. Jerome, along with William K. Vanderbilt and other investors, founded the Coney Island Jockey Club, which in 1884 built the Sheepshead Bay Race Track. Jerome, the grandfather of Winston Churchill, died in England. Both Jerome Avenue, a main Bronx thoroughfare, as well as a Brooklyn road that led to the now defunct track were named in Jerome's honor.

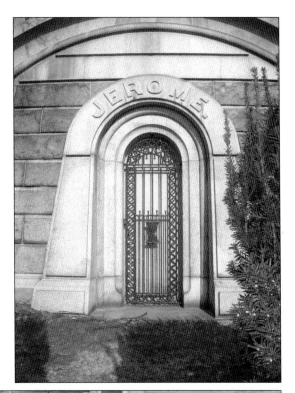

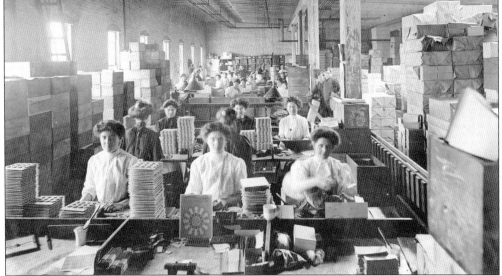

Eberhard Faber brought German pencil-making techniques to America. His factory in Greenpoint was considered one of Brooklyn's most important factories, employing hundreds of local workers, a majority of whom were women. The factory complex was declared a historic district in 2007. Eberhard Faber Company Historic District has many of the original structures intact. The buildings were decorated with stone lintels containing the company name. Faber died at the age of 57 after a long illness. In accordance with his wishers, Faber's funeral was private. This photograph shows workers in the Eberhard Faber boxing and labeling department. (Courtesy of the Brooklyn Historical Society.)

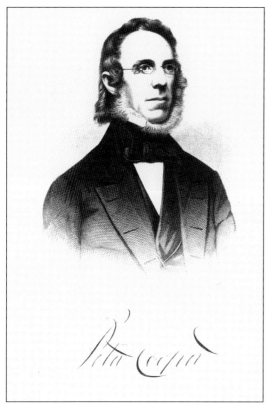

The son of Dutch immigrant parents, Peter Cooper became a fabled American inventor, industrialist, philanthropist, and presidential candidate. Cooper's most notable invention in 1833 was the steam locomotive known as the *Tom Thumb*. He also created a railroad ironworks that became known as Trenton Iron Works, located in New Jersey. In 1858, he endowed an art school, the Cooper Union for the Advancement of Science and Art, which remains tuition free as Cooper desired. Each student receives a full scholarship. Cooper also obtained the first American patent for the manufacturing of gelatin, known today as Jell-O. When Cooper died in 1883, more than 1,000 people lined up to view his body in Manhattan's All Souls' Church. In a sign of respect, hats were doffed by spectators as the funeral procession made its way to the ferry that would transport Cooper to Green-Wood. (Left, courtesy of the Library of Congress; below, courtesy of the Green-Wood Historic Fund.)

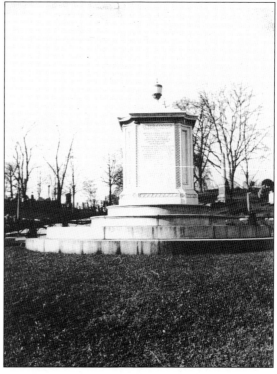

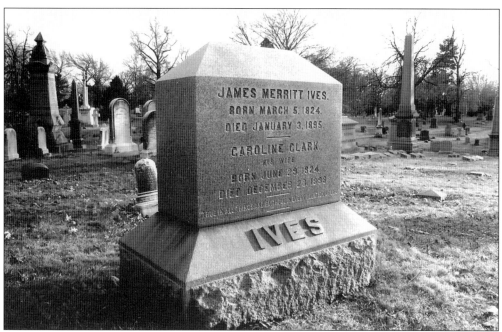

After apprenticing at the Boston printing firm of William and John Pendleton, the United States' first successful lithographers, Nathaniel Currier moved to New York City, where, in 1835, he began his own lithographic business. In 1850, James M. Ives was hired as the firm's bookkeeper, and seven years later, in 1857, Ives was made a full partner in what became known to the world as Currier and Ives. Currier and Ives became synonymous with scenes of Americana. Among the noteworthy illustrations were lithographs that depicted politics, landscapes, and holidays. The approximately 7,500 works produced by the company became prized by collectors throughout the world. Also buried in Green-Wood is Fanny Palmer (née Frances Flora Bond), who illustrated many prints for Currier and Ives while in their employ.

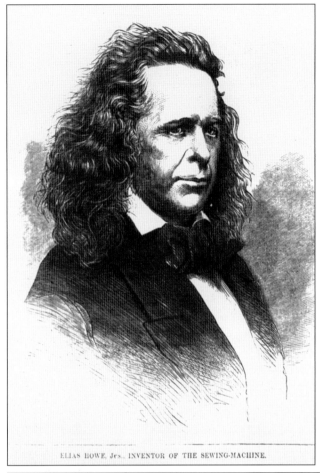

ELIAS HOWE, Jrs., INVENTOR OF THE SEWING-MACHINE.

Elias Howe was an American inventor credited with inventing the sewing machine. Actually, he patented the lockstitch design, the sewing machine's most common stitch. He was granted a patent for the lockstitch in 1846 but in 1854 entered into litigation with Isaac Singer, who was using Howe's patented stitch and incorporating it into Singer sewing machines. Howe successfully sued and earned royalties, much of which he donated to the Union army during the Civil War. Howe died at age 48 in 1867 a wealthy man. Coincidentally, it was the same year his patent expired. He is buried with his wife, Rose, and the couple's dog Fannie, who has her own gravestone on which a poem is inscribed. (Left, courtesy of the Library of Congress; below, courtesy of the Green-Wood Historic Fund.)

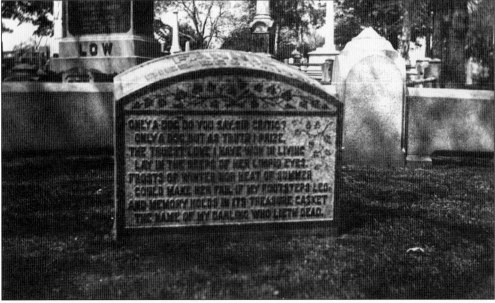

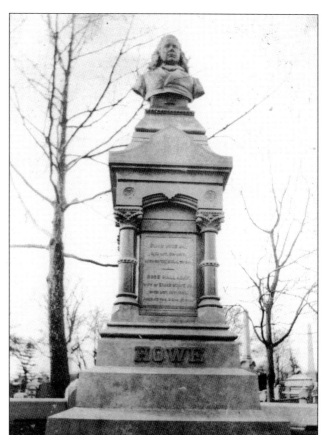

These vintage photographs show Howe's grave, most likely taken around the dawn of the 20th century. The site at the time these photographs were taken shows young vegetation. Today trees and bushes have grown within the stone enclosure. (Courtesy of the Green-Wood Historic Fund.)

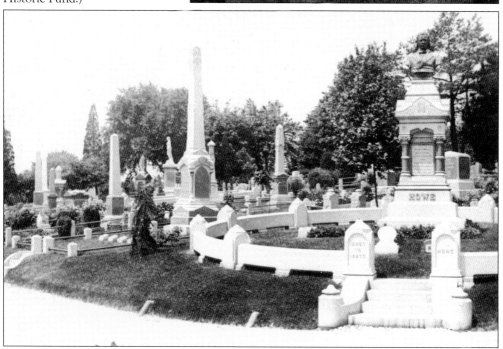

In 1849, German-born Charles Pfizer and a cousin used $2,500 in borrowed money to start a company in the Williamsburg section of Brooklyn. The company, which bore the Pfizer family name, expanded its line of pharmaceutical products. The quality of Pfizer products became synonymous with excellence. The company moved in 1857 to the Wall Street area of Manhattan, where it also used one of the first city telephones. Pfizer died in 1906 at the age of 82. (Courtesy of Pfizer Inc. All rights reserved.)

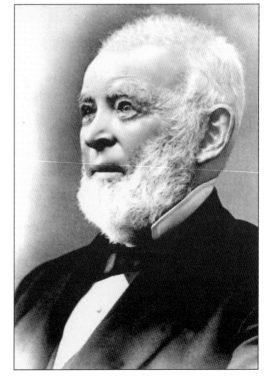

Dr. Edward R. Squibb received a medical degree in 1845 and for 10 years served as a naval surgeon before becoming an assistant director of the U.S. Naval Laboratory, stationed in the Brooklyn Navy Yard. In 1856, he developed an apparatus to distill ether used during the Civil War. Squibb left the navy in 1857 and set up a pharmaceutical business in Brooklyn, which provided medical supplies to Union forces. The firm became the Squibb Corporation, which prospered well after his death in 1900. (Courtesy of Bristol-Myers Squibb.)

The Tiffany family is buried in relative simplicity in a family plot. Both father and son left indelible imprints on the world, creating much-desired products synonymous with wealth, taste, and luxury. Charles Lewis Tiffany (right) began a stationery and fancy goods store, which ultimately developed into a major jeweler known worldwide as Tiffany and Company. Today Tiffany and Company has 150 locations around the world and annual sales of about $2 billion. When Charles Lewis Tiffany died in 1902, at the age of 90, major jewelers closed during his funeral as a sign of respect. His son, Louis Comfort Tiffany (below), was a Brooklyn painter who became interested in glassmaking and worked at a glass house in Brooklyn. Experimenting with inexpensive mason jars, Tiffany soon perfected the art of stained glass. Examples of his windows and lamps can be seen at Green-Wood and in churches and homes around the country. (Right, courtesy of the Green-Wood Historic Fund; below, courtesy of the Library of Congress.)

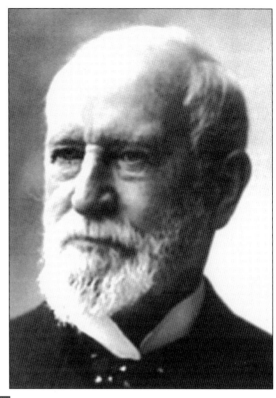

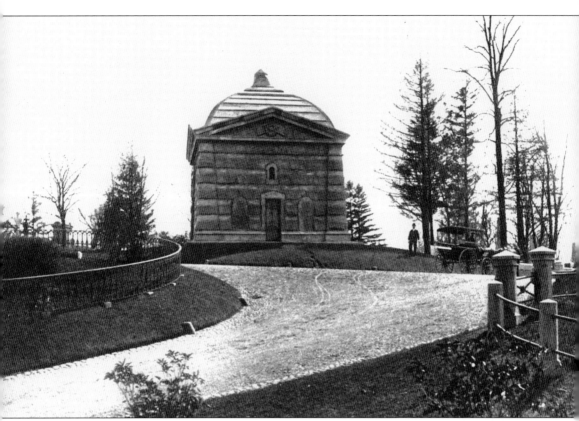

Orphaned as a teen, Henry Steinway, born Steinweg, worked as a carpenter and as an apprentice to an organ manufacturer. Steinway played the organ in church and began to build small instruments and eventually a small piano, giving the first one to his wife as a wedding present. After immigrating to the United States from Germany with his wife and four sons, Steinway worked for piano makers in New York. In 1853, Steinway started his own company, Steinway and Sons. The firm won first prize in the New York Industrial Fair of 1855, and before long, Steinway's concert pianos became synonymous with quality and craftsmanship. Steinway died in 1871 at the age of 74. A year before he died, Steinway purchased land in Astoria, Queens, where he moved his business. The company remains in Queens to this day. A main thoroughfare in Astoria, Queens, is named for Steinway. Pictured is the impressive stone Steinway mausoleum located on a hilltop. This *c.* 1890 photograph shows a man standing near a horse-drawn carriage. (Courtesy of the Green-Wood Historic Fund.)

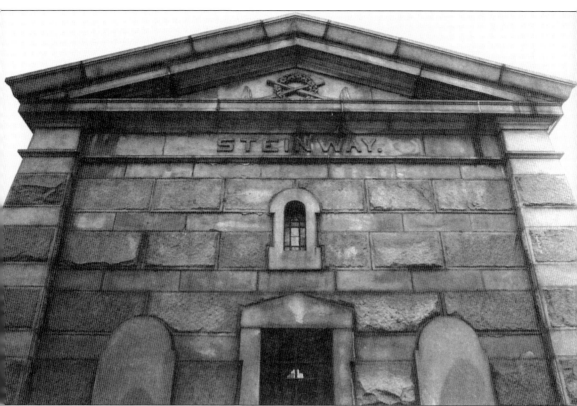

This modern photograph of the Steinway mausoleum shows the stately grandeur of the edifice. Noted in the middle of this facing wall is a stained-glass panel. The structure is sometimes opened for cemetery events such as Open House New York, and a Steinway piano has been brought in to provide music.

In 1886, Josephine Lemmonier Newcomb founded H. Sophie Newcomb Memorial College Institute for Women in New Orleans, Louisiana. The college was established as a tribute to her daughter Sophie, who died in 1870 at the age of 15 from diphtheria. As a part of Tulane University, Newcomb College became the first degree-granting coordinate college—a college within a larger university—for women in America. This model was adopted by other educational institutions. Newcomb died in 1901 at the age of 87 in New York, leaving the bulk of her estate, valued at over a million dollars, to the school. She is buried with her husband and daughter Sophie (shown below). A memorial stone, donated by the Friends for Newcomb College, rests in front of the family monument and makes note of her establishment of the college. The long and proud history of the college continues today. (Courtesy of the Vorhoff Library and Newcomb Archives, Newcomb College, Tulane University.)

Five

MAUSOLEUMS, MONUMENTS AND SPECIAL MEMORIALS

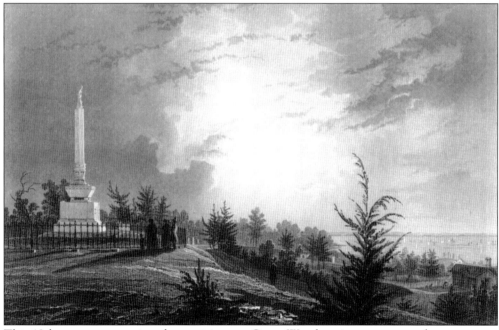

This 19th-century engraving shows visitors to Green-Wood paying respects at the monument to nautical pilot Thomas Freeborn. Freeborn was one of the casualties aboard the *John Minturn*, the vessel that ran aground off New Jersey in February 1856. (Courtesy of the Green-Wood Historic Fund.)

The noted 19th-century sculptor Patrizio Piatti was connected to Green-Wood in life and death. Piatti worked on several monuments at Green-Wood: the sea captain's monument, the Griffith Memorial, the monument to Col. Abraham S. Vosburgh, and that of Maria Whitlock. Piatti died of apparent accidental asphyxiation from carbon monoxide in his Manhattan apartment in July 1888. He was 64 years old and had taken a volume of *Plutarch's Lives* with him to bed the night he died. Piatti's name does not appear on the memorial.

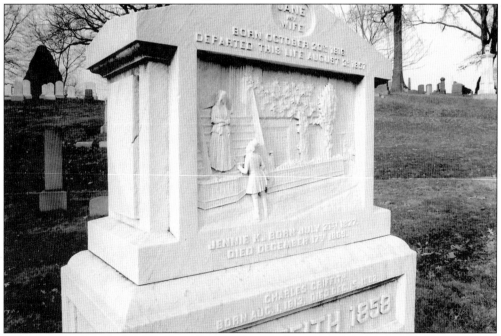

After Jane Griffith died suddenly at the age of 41 on August 4, 1857, her heartbroken husband commissioned noted sculptor Patrizio Piatti to create a stone panel depicting her last day of life. The stone shows Jane saying goodbye to her husband, Charles, on the steps of their home as he left for work, only to return later to find her dead.

This Angel of Grief monument is a replica of an 1890s sculpture by noted American sculptor William Wetmore Story. Originally Story sculpted the first one of Carrara marble for the grave of he and his wife in Rome. Since that time a number of replicas have been made, including this one for the 1908 grave of Aurelia Cassard. Note the missing left hand of the angel.

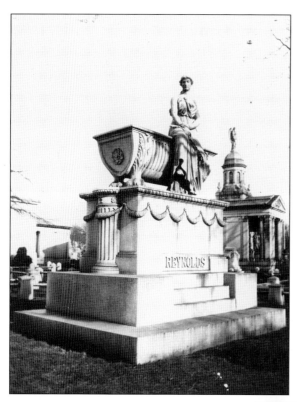

The Reynolds sarcophagus is often referred to as the "bathtub" because of its resemblance to the bathroom fixture. It has a rectangular shape and is located by the Fort Hamilton Parkway entrance. (Courtesy of the Green-Wood Historic Fund.)

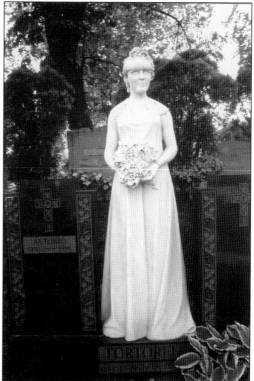

This monument, commonly referred to as "the Bride," depicts a young woman in a dress, holding a bouquet of flowers. It attracts tourists because of its stately simplicity and innocence.

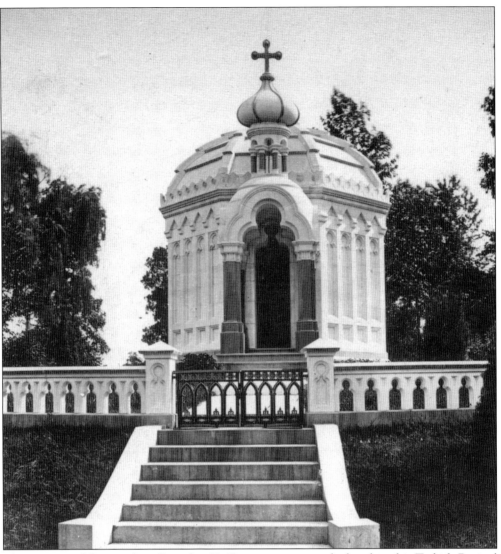

The remains of Commodore Cornelius K. Garrison are entombed within this Turkish Revival mausoleum, reminiscent of a sultan's turban. Born to a wealthy family, Garrison saw the family fortune diminish. He worked the riverboat trade and at the age of 16 studied architecture and engineering. He later started a large steamship company, hence the title commodore. He was mayor of San Francisco from 1853 to 1854. Garrison invested heavily in railroad enterprises and scored a financial killing when robber baron Jay Gould had to pay him handsomely to acquire one of his rail routes. Garrison also invested in gas-manufacturing systems in major U.S. cities but suffered severe financial reverses in the 1880s. Garrison was getting back into business after paying down debts when he died in May 1885. The *New York Times* headline declared him "suddenly stricken with paralysis of the heart." Garrison's body reposed in the rear parlor of his Park Avenue home. Among the many floral tributes was a piece in the form of an anchor. The fence, seen in this *c.* 1870 photograph, has been removed. (Courtesy of the Green-Wood Historic Fund.)

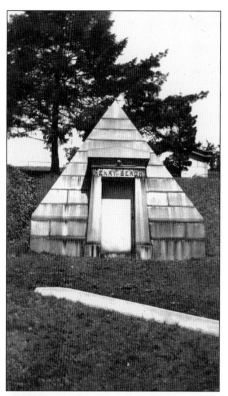

ASPCA founder Henry Bergh died during the blizzard of 1888. His body was placed in the receiving vault of St. Mark's Church because Green-Wood was covered with snow. The funeral procession to St. Mark's Church could hardly be seen in the streets because of the mounds of snow. Mayor Abram Hewitt was a pallbearer, and showman P. T. Barnum was in attendance, as were representatives of many animal protection associations. The *New York Times* noted that because of the snow "the body will be taken to Green-Wood when the roadways are passable." (Courtesy of the Green-Wood Historic Fund.)

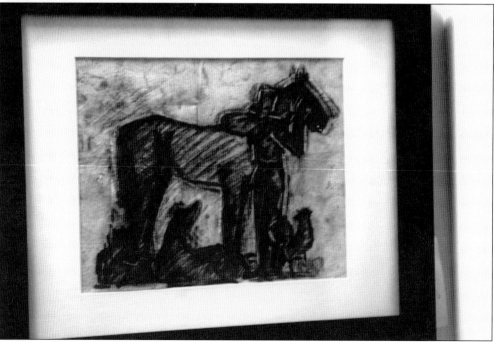

This photograph is of an original drawing by Wilhelm Hunt Diederick that served as the basis for the sculpture at the foot of the Bergh grave. The cemetery purchased this original drawing, and it hangs in the executive offices at Green-Wood.

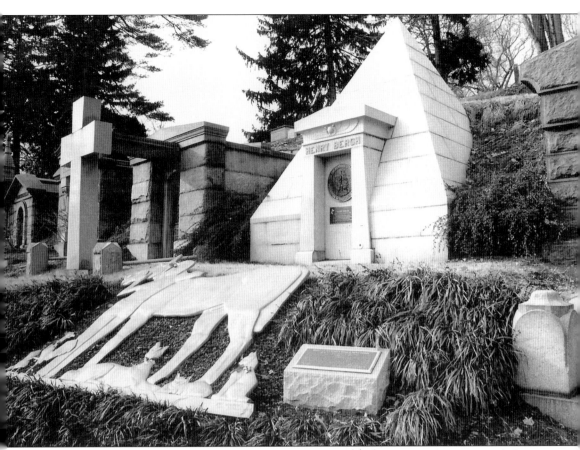

In 2006, the bas-relief sculpture pictured here, commemorating Henry Bergh, was unveiled to the public in a ceremony in which people were allowed for the first time in over a century to bring their pets into the cemetery. Green-Wood has also hosted an exhibit honoring Bergh in its chapel. Also buried in Green-Wood is Louis Bonard, who willed his substantial estate to the ASPCA. In addition, Rex the poodle and Fannie the dog are buried on the grounds with their own monuments. Other examples of animals used in commemoration include the Beard monument, depicting a bear, and the Seaman monument, which depicts a horse.

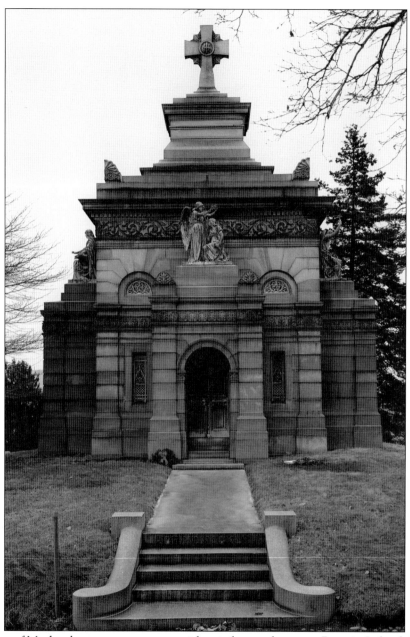

The name of Mackay became synonymous with privilege and success. Born in Ireland, John W. Mackay came to New York with his parents in 1840. As a young man, Mackay traveled to California, where he worked in gold mines and later formed mining partnerships. Mackay developed one of the biggest Nevada silver mines in the period around and after the Civil War in what was known as the Comstock Lode. In 1898, Mackay ordered the family mausoleum built after the untimely death of his son, also named John. Mackay's granite mausoleum cost $300,000, has bronze doors, stained glass, and an altar, and is the only one in the cemetery with heat and electricity. Mackay, known as the "bonanza king," died in July 1902 in London, but his body was not returned to New York until November. An undertaker met the ship at the pier and took Mackay's body directly to Green-Wood.

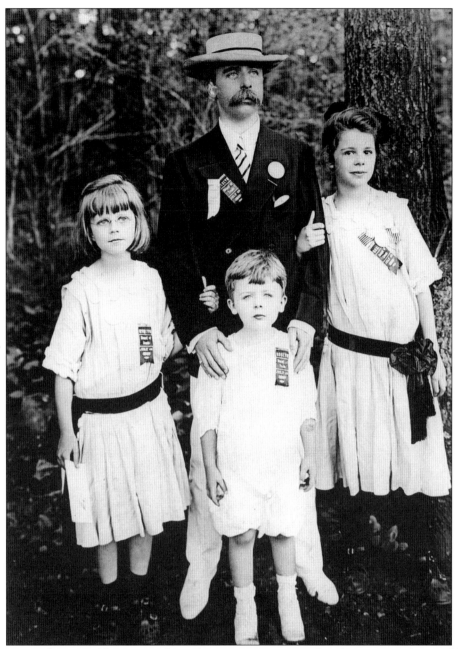

In 1898, Mackay's son Clarence, a telegraph entrepreneur, married Katherine Duer. As a wedding gift, Mackay and his wife gave the couple an estate known as Harbor Hill in Roslyn, Long Island. Said to be the largest home ever designed by famed architect Stanford White, Harbor Hill was one of the Gold Coast's foremost showplaces. Although Clarence inherited the bulk of his father's fortune, he disinherited his daughter Ellin, shown on the left in this *c.* 1914 photograph of Clarence and his children, after she married Irving Berlin against his wishes. Katherine Duer Mackay funded Trinity Episcopal Church in Roslyn, designed by Stanford White, in memory of her parents. Louis Comfort Tiffany created some of the church's windows. (Courtesy of the Bryant Library Local History Collection, Roslyn, New York.)

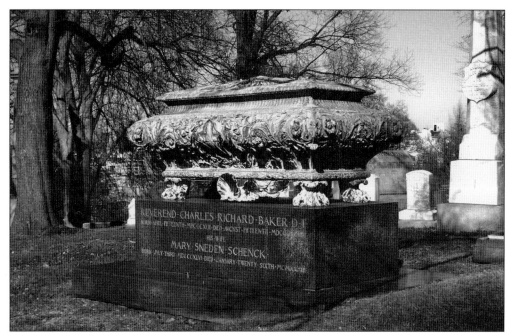

Rev. Charles Richard Baker served for 25 years as rector of the Protestant Episcopal Church of the Messiah, located at Greene and Clermont Avenues in Brooklyn. As clergy, he officiated at the funeral of Gen. Henry Slocum. Baker died in 1898 at the age of 56 while traveling in Europe. In 1901, a memorial window was dedicated at the church.

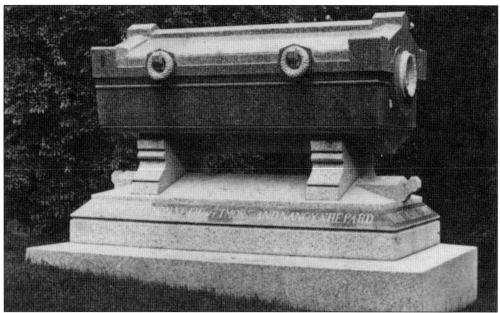

The wealthy merchant William Shepherd Wetmore was born in New England and was mentored by relatives in the merchant trading business. In his career Wetmore developed a number of businesses, including those that imported tea from Asia. After retiring, Wetmore lived in Rhode Island and is credited with building Chateau-sur-Mer, the first of the large mansions of the Gilded Age in Newport, which is open to the public. (Courtesy of the Green-Wood Historic Fund.)

This beautifully detailed statue is of a grandfather and his beloved granddaughter, who died a year apart and are buried together. Peter Lawson was 84 when he died; his granddaughter Jensine Gomard was 24. She is depicted holding a rose and under her name is inscribed, "The Earth, the Earth / Has Lost a Gem. / Heaven Has Gained a Star. / The Angels Saw It / Shining Here, / And Called It from Afar."

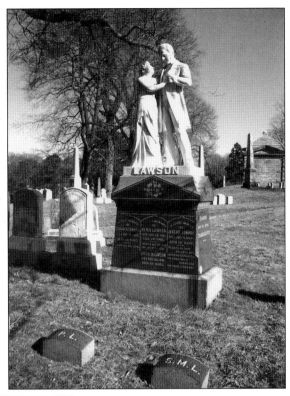

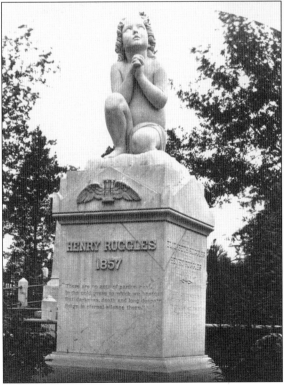

The "Big Baby" is a larger-than-life statue of a baby, commemorating little Henry Ruggles, who died in 1857. Green-Wood sometimes uses this monument as a landmark for directions on cemetery grounds. This poignant statue of Ruggles is emblematic of the many deaths of children. Other statues symbolize the death of babies: "Precious Georgie" and "Baby Thom" are just a few. Sculptures of lambs and children's furniture have also been used as monuments. (Courtesy of the Green-Wood Historic Fund.)

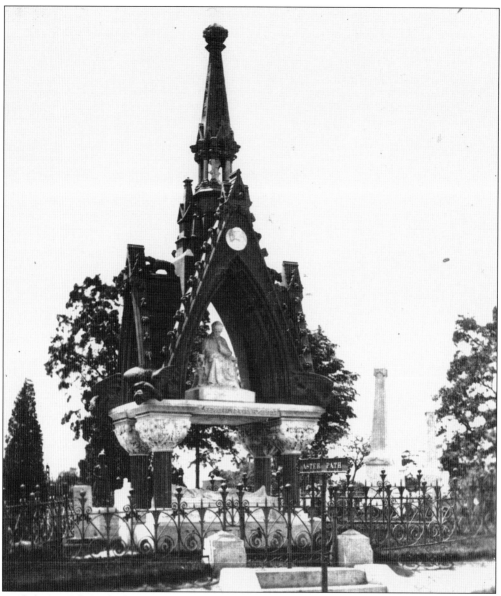

Englishman John Matthews created carbonated drinks. His monument, which he helped to design, was voted "mortuary monument of the year" in 1870, the year it was built. Carbonated water had been available in Europe, but it was Matthews who sold air-charged water to retail stores and also provided them with soda fountains. His manufacturing plant on Gold Street in Manhattan used the reaction between sulfuric acid and marble dust to produce carbonic acid gas that was purified and sold. Matthews used scrap marble from construction sites like that of St. Patrick's Cathedral to use in his process. The popularity of Matthews's process earned him the title of the father of the soft drink industry. (Courtesy of the Green-Wood Historic Fund.)

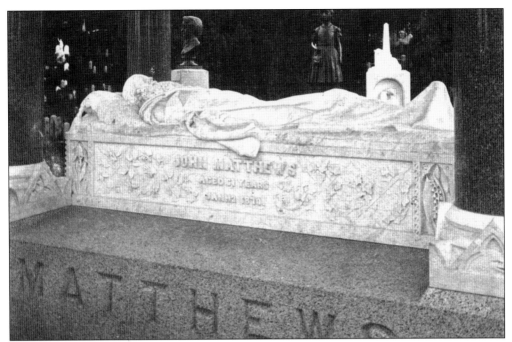

Seen in this close-up view of the Matthews monument is a detailed sarcophagus. The monument bears a resemblance to the King Albert Memorial in London. (Courtesy of the Green-Wood Historic Fund.)

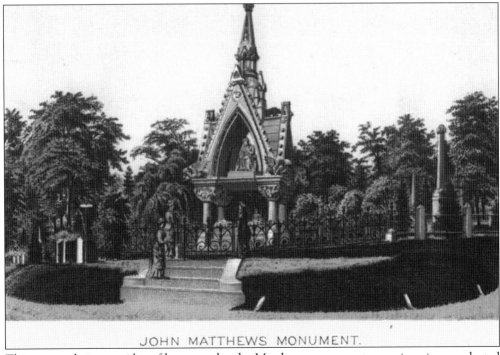

JOHN MATTHEWS MONUMENT.

This postcard gives an idea of how popular the Matthews monument was, since it was selected for its own card. The monument is depicted with a metal gate, which is no longer present. Note the women by the steps. (Courtesy of the Green-Wood Historic Fund.)

The firemen's monument, seen in this *c.* 1870 photograph, is in honor of volunteer firemen George Kerr and Henry Fargis, who lost their lives in a fire in lower Manhattan in 1848. Erected by the volunteer firemen of New York City, the statue is rich in symbolism. The memorial is topped by the statue of a fireman rescuing a child. Although they cannot be seen, George Kerr's grave is on the left, and Henry Fargis's stone is on the right. (Courtesy of the Green-Wood Historic Fund.)

The sea captain monument, seen in this *c.* 1870 photograph, memorialized Capt. John Correja, who died in 1910. Correja enjoyed spending time at Green-Wood and would sometimes bring friends to the site that would become his memorial for picnics and outings. Correja brought back marble from Italy to be used in his own monument, which originally had a sextant, a navigational aid, in Correja's hands. (Courtesy of the Green-Wood Historic Fund.)

This detail of the memorial to the steamship *Arctic*, which was lost at sea in 1854, is shown in a photograph from 1875. The ship, which was badly damaged after colliding with the French vessel *Vesta*, is shown as it slipped beneath the waves. Only about 24 of the 182 passengers survived while about 40 percent of the crew, which had commandeered most of the lifeboats, made it to safety. (Courtesy of the Green-Wood Historic Fund.)

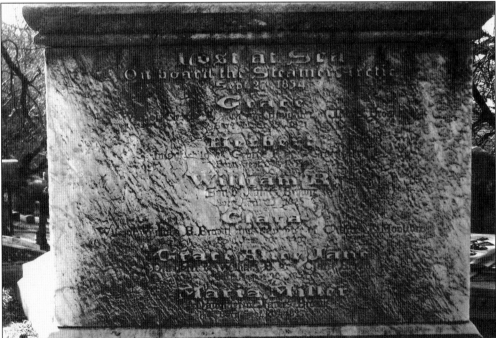

James Brown, president of the Collins Line, which owned the *Arctic*, commissioned noted sculptor John Moffitt to create the monument to memorialize six members of the Brown family who perished in the tragedy. The weathered stone lists the names of the family members.

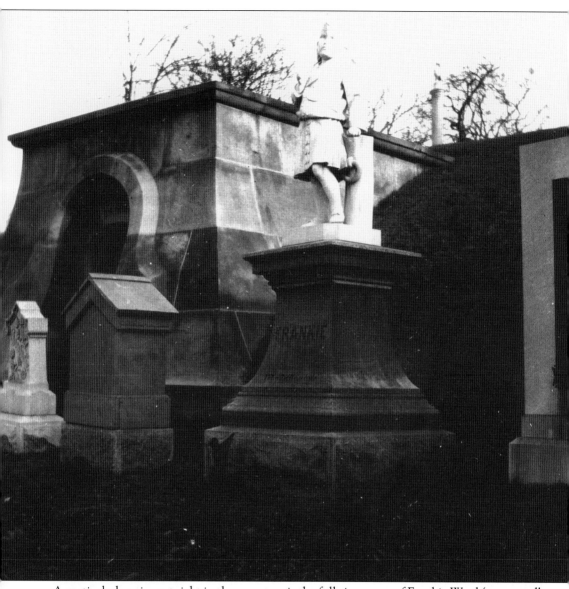

A particularly poignant sight in the cemetery is the full-size statue of Frankie Ward (purportedly by Daniel Chester French), who died as a youth, dressed in a sailor suit. Inscribed on the base of the monument is the sentiment "Yet a little while." Frankie's father, Rear Adm. Aaron Ward, the son of a general, is buried in an adjacent grave along with his wife. Ward was considered an expert on torpedoes and explosives and spoke five languages, including Russian. Apart from his fame as a naval officer, Ward was also known here and abroad for his prized rose garden, in which there were more than 3,000 rosebushes. Ward named one of his roses Mrs. Ward for his wife. Ward is said to have kept in his garden a ship barometer, to aid him in his gardening work. Ever charitable, Ward donated the proceeds of a small book he wrote, *One Year of Rose Work*, to the American Ambulance Fund. Ward died in 1918 at his home Willowmere in Roslyn, Long Island. (Courtesy of the Green-Wood Historic Fund.)

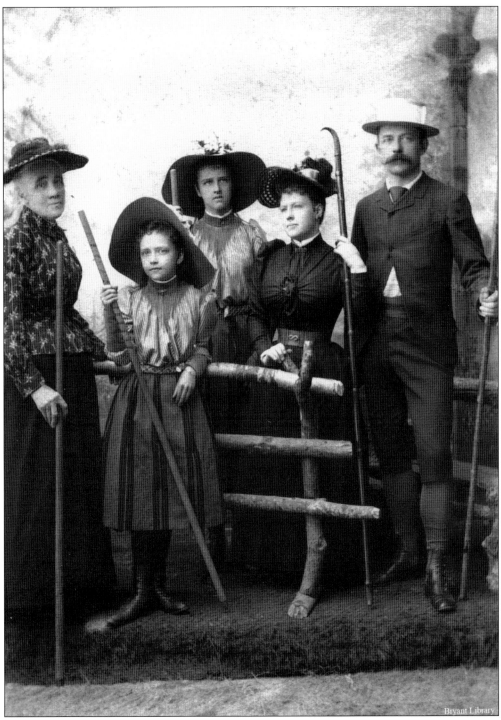

This *c.* 1894 photograph of the Ward family taken several years after Frankie's death shows Rear Adm. Aaron Ward, his wife, Annie, and daughters, Hilda and Edna, in a light moment. They appear to be posing as hikers in a studio setting. Also on the left is a member of the Ward household staff. (Courtesy of the Bryant Library Local History Collection, Roslyn, New York.)

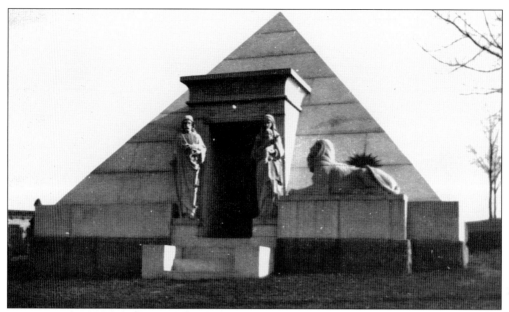

The unusual pyramid-shaped mausoleum of author Albert Ross Parsons (1847–1933) mixes Christian religious statuary with Egyptian symbolism. Parsons was considered an expert on pyramids, authoring a book *The New Light from the Pyramids*. But archaeology was not Parsons's only passion. He was also greatly involved in music, playing the organ in church and composing his own musical works. He also taught the piano. Parsons made his home in Garden City, Long Island. (Courtesy of the Green-Wood Historic Fund.)

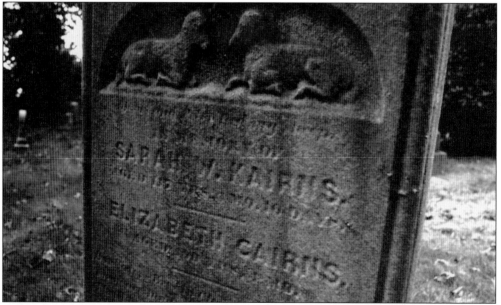

Perhaps the oldest person to be buried at Green-Wood is Sarah Kairns, who was said to have been 117 years old when she died from asthma in 1854. In her life she gave birth to 22 children. The lettering on her limestone grave marker, which stands close to a cemetery road, is weathered from age and almost illegible. She is buried along with her sister, Elizabeth, who preceded her in death at the age of 100.

One of New York City's best-known millionaires, Gordon W. Burnham, president of the Waterbury Clock, Waterbury Watch, and the American Pin Companies, refused to marry his fiancée, author Kate Sanborn, under a Republican administration. On March 19, 1885, with a Democrat as president, he caught a cold, which turned to pneumonia as he waited at the ferry for his fiancée. Burnham was buried on the day his wedding was to have taken place. James S. T. Stranahan and his attending physician were honorary pallbearers. The sculpture atop Burnham's grand monument was designed by sculptor John Moffitt. (Courtesy of the Green-Wood Historic Fund.)

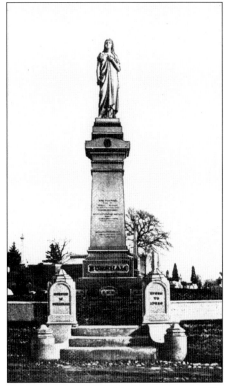

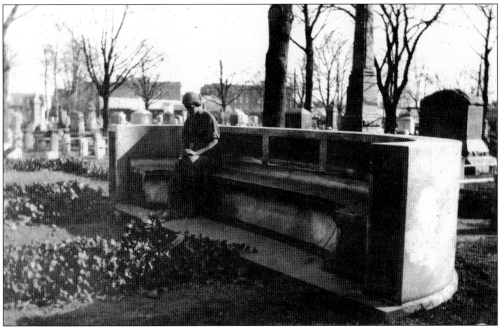

This stone bench, shown in an early-20th-century photograph, is unusual because it contains a sculpture of a pensive woman looking at the graves before her. The design is indicative of many unique styles of monuments that Green-Wood contains. (Courtesy of the Green-Wood Historic Fund.)

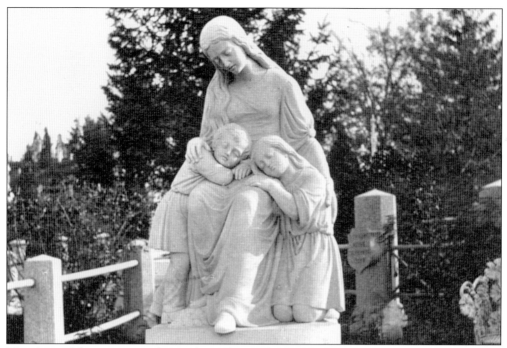

This beautiful monument, dating from the mid-19th century, is emblematic of the many Green-Wood monuments that honor and memorialize mothers and children. (Courtesy of the Green-Wood Historic Fund.)

McEvers Bayard Brown was an eccentric millionaire and founding member of Georgia's famed Jekyll Island Club who spent 36 years living aboard his yacht *Valfreya*, anchored off England's Essex Coast. Brown, known as "the Hermit of the Essex Coast," died in 1926. Despite a pouring rain the day of his funeral, the entire population of the English town of Vivenhoe attended the service. His remains were later transported aboard his yacht to New York City for his burial. Brown is entombed in one of the Cutting family mausoleums located in this section. The Cutting family was part of an affluent New York business aristocracy that founded the fabled Fulton Ferry.

Six

Young, Tragic, and Notorious

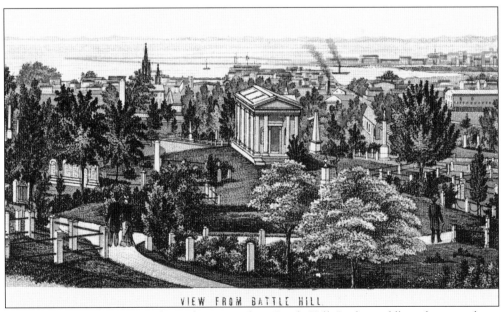

VIEW FROM BATTLE HILL

This print shows the view in the 19th century from Battle Hill. In the middle is the mausoleum of John Anderson. In the background are Manhattan and the harbor of New York. (Courtesy of the Green-Wood Historic Fund.)

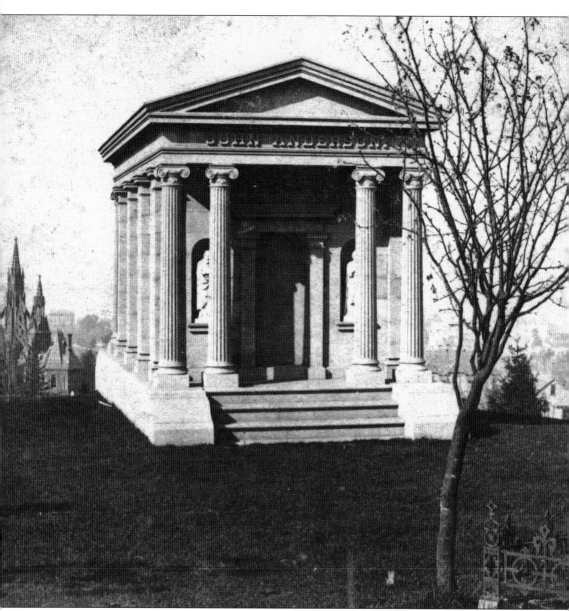

John Anderson, who made a fortune in tobacco, became a suspect in the 1842 murder of Mary Rogers, one of his young employees. The case was a tabloid newspaper sensation and even inspired a book by Edgar Allan Poe. Anderson was arrested for the murder, but nobody was ever convicted. Anderson died in Paris in November 1881. His body was returned to New York City in January 1882 for his funeral. A religious service was held for Anderson at Trinity Church, after which he was entombed in the imposing Greek Revival family mausoleum, which is prominently situated on the cemetery grounds. (Courtesy of the Green-Wood Historic Fund.)

Sallie C. Koop, 28, was a beautiful young woman and a member of a well-known Brooklyn Heights family. Koop, said to be despondent over the marriage a week before of her twin sister, committed suicide in her Montague Street home in 1893. Seven years later, Sallie's brother, Herman H. Koop, one of the leading men of Brooklyn society, shot himself in the head at the grave of his father. Friends believe he was grieving over his father's death the previous year.

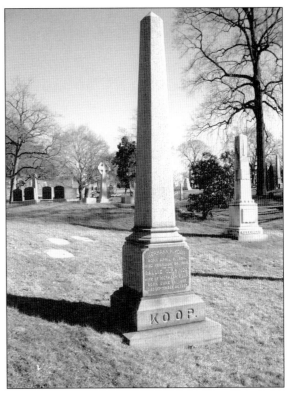

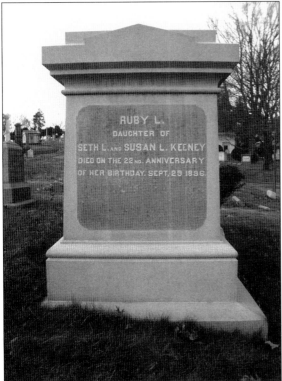

The story of lovely and sweet young Ruby Louise Keeney is a sad one. Keeney was only 15 when her mother died. Her father was a trustee of the Brooklyn Bridge Company but was arrested for misappropriation of funds. In 1898, Keeney became ill with consumption and was taken by her family to the Adirondack Mountains to be treated. Sadly it was to no avail. Keeney died on her 22nd birthday, a fact noted on her family monument.

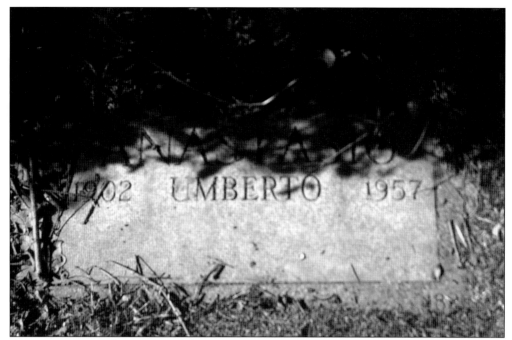

An inconspicuous footstone with his given name of Umberto Anastasio marks the grave of Albert Anastasia, a prominent member of Murder Incorporated. Anastasia's funeral was a subdued affair attended only by his close relatives. The crime bosses he had once associated with were absent. His burial service at Green-Wood was brief and attended only by a dozen family members, although more than 200 bystanders peered through the cemetery fence.

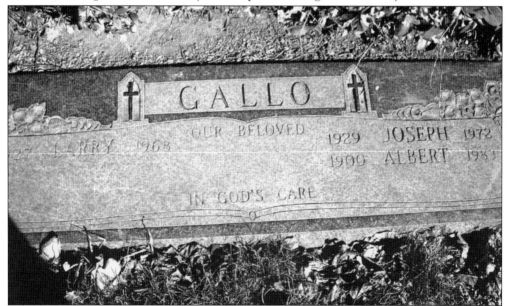

Joey Gallo, known as "Crazy Joe," was a New York gangster who was gunned down on April 7, 1972, at his 43rd birthday celebration, inside Umberto's Clam House in New York City's Little Italy section. Staggering outside, he fell dead at 5:23 a.m. in front of his car. His sister bent over the body, shrieking, "He was a good man; he changed his image!"

Henry Barnet's death became the backdrop to a pair of sensational New York City murder trials of Roland Molineux. Barnet was Molineux's rival for opera singer Blanche Chesebrough, whom Molineux ultimately married. Police suspected Molineux killed Barnet and Katherine Adams, a landlady. Barnet's body was exhumed from his Green-Wood grave in 1899 and found to contain poison. Molineux was never charged in Barnet's death and was acquitted of killing Adams. The case spawned the Molineux rule, controlling the admissibility of certain evidence in criminal trials.

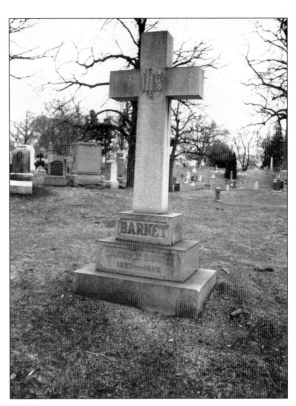

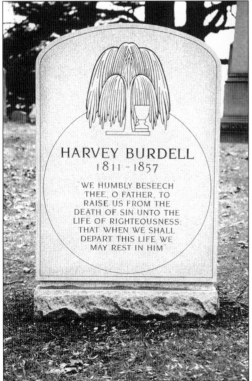

Dentist Harvey Burdell was allegedly murdered in his office by Emma Hempstead Cunningham and an accomplice in 1857. Cunningham was found not guilty. Author Benjamin Feldman recounts this tale in his 2006 book *Butchery on Bond Street*. Green-Wood and Feldman shared the cost of erecting a new monument for Burdell, which was unveiled in 2007.

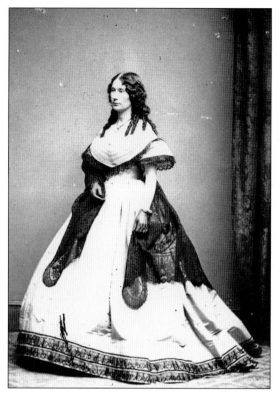

Actress Laura Keene also managed her own theater—the Laura Keene Theatre—and it was her company that was onstage at Ford's Theatre the night Pres. Abraham Lincoln was assassinated in 1865. Keene was acting in the play *Our American Cousin* when Lincoln was shot and quickly made her way to his box seat. Reportedly she was allowed to cradle Lincoln's head on her lap as he lay mortally wounded. Lincoln's wound stained her dress, and for a time the clothing was one of the most viewed relics of the incident. Keene was sometimes asked to model the dress, bloodstains and all. (Courtesy of the Library of Congress.)

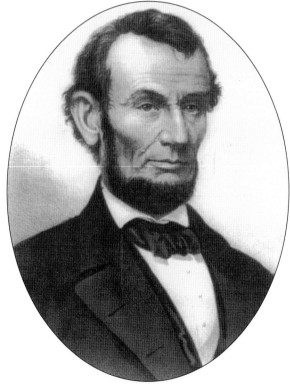

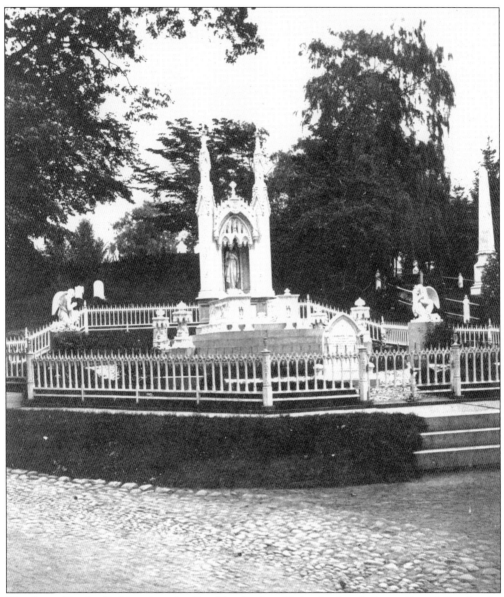

Charlotte Canda died in what the *Brooklyn Eagle* called a "melancholy accident." Canda, the daughter of French parents who ran a finishing school, was thrown from a carriage and killed instantly. After a coroner's inquest, the *Brooklyn Eagle* reported that "the verdict was death in accordance with the lamentable accident and the injuries received by the fall." For her funeral, Canda was said to have been laid out in white satin sheets. Her monument, which she originally had designed for an aunt, cost in excess of $20,000 and commemorates her untimely death. The monument notes that "On Monday, Charlotte Canda died suddenly by falling from a carriage on the night of the 3rd of February 1845 being the seventeenth anniversary of her birthday." Canda's fiancé, Charles Albert Jarrett de la Marie, who committed suicide, is buried nearby. (Courtesy of the Green-Wood Historic Fund.)

In 1898, Reinhold Penzel was found dead by the grave of his baby daughter, Frederica, who died in 1882. Among his possessions recovered by police were several sealed letters, one addressed to his wife and another letter written in German to a Brooklyn reverend, imploring him to watch over his wife. No mention was made of his intention to commit suicide. In addition to the letters, an empty bottle and a tin cup were found next to Penzel's body.

Poet and author William North, depressed over having not received the public acclaim he felt his due, committed suicide at the age of 29 in November 1854. Dressed in a new black suit, said to have been ordered for the occasion, North drank poison in his room. Beside his bed he left the final pages from his autobiographical novel *The Slave of the Lamp*. When the book was published posthumously in the spring of 1855, the *New York Times* noted, "The Slave of the Lamp is a remarkable work. It is brilliant, original, well-devised, and powerfully written."

Alice Hathaway Lee Roosevelt, the first wife of Pres. Theodore Roosevelt, died on Valentine's Day in 1884, two days after giving birth to their daughter, Alice, Roosevelt's only child. In a poignant coincidence, President Roosevelt's mother, Martha Roosevelt, died on the same day. They are buried together in the circular arrangement that comprises the Roosevelt plot. Many of the stones are faded with age.

Brooklyn-born songwriter Paul Jabara got his start by performing in the 1960s Broadway production of *Hair*. In 1977, the song "Last Dance," which he wrote for Donna Summer, won the Grammy. Jabara was himself honored with an Oscar and a Golden Globe. Sadly, Jabara died in 1991 at the age of 44. The song he was working on at the time of his death, "Mistaken Identity," was sung at his funeral.

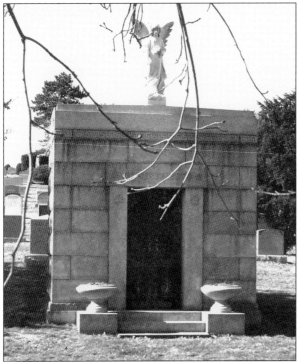

Johnny Torrio was a key leader in the Chicago mob and a mentor to Al Capone. Torrio later testified at Capone's tax evasion trial, which resulted in Capone being sent to prison, where he died. Torrio became a power in the New York Genovese crime family and was a proponent of implementing a national crime syndicate. Torrio died of a heart attack in a barber's chair in 1957.

Folklore has it that the monument depicting a prostrate woman lying on stone steps symbolizes a Mafia bride who lost her husband to murder on their wedding day. It is more likely that the statue represents the grief surrounding the death of 35-year-old Rose Guarino. The daughter of affluent Brooklyn widow Domenica Merello, Guarino died in a shooting spree in the family's New Jersey summer home. It was during this 1909 incident that Guarino, attempting to shield one of the servants from an assailant, was mortally wounded.

CLARA MORRIS,
AS CAMILLE.

256 FIFTH AVEN

Separated as children, Eliza Burtis, who is buried at Green-Wood, never knew, although she suspected, that famous stage actress Clara Morris was her sister. When Morris died in 1925, newspapers hailed her as a "noted tragedienne," citing *Camille* as one of her finest works. After a protracted search following Morris's death, a newspaper reporter helped the elderly and impoverished Burtis come into her share of her sister's estate. Sadly, Burtis never reaped the benefits of her inheritance. She died within a month of the *New York Times* article titled "Find Needy Sister of Clara Morris," which described how she had been reunited with her legacy. Burtis is buried in the family plot shown below. Morris's husband, Frederick Harriot, is also buried on the grounds. (Left, courtesy of the Library of Congress.)

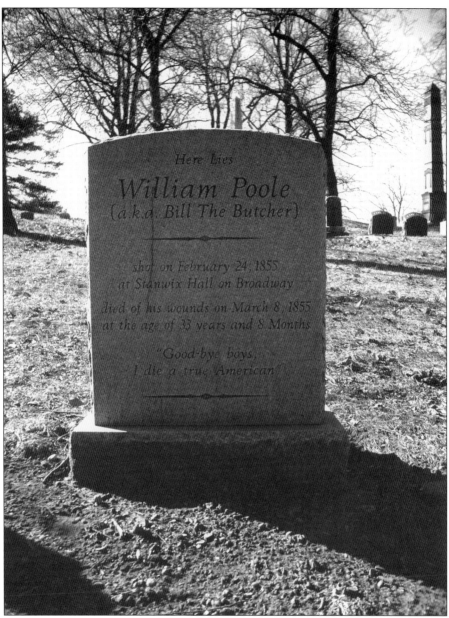

Here Lies
William Poole
(a.k.a. Bill The Butcher)

shot on February 24, 1855
at Stanwix Hall on Broadway

died of his wounds on March 8, 1855
at the age of 33 years and 8 Months

"Good-bye boys,
I die a true American"

In the 19th century, William "Bill the Butcher" Poole was reputed to be the toughest gangster in New York. A butcher by occupation, Poole led a gang of street toughs on the Lower East Side. Poole was a dirty fighter who would gouge opponents in the eye. He had grown up with the Bowery Boys and formed his own gang. His opponent was another gang leader, John Morrisey, who was badly beaten by Poole the night of February 24, 1855. Three of Morrisey's cohorts retaliated and shot Poole in the heart. Poole, 33, lingered for two weeks before dying with the words "Good-bye boys, I die a true American." His funeral had about 6,000 mourners, and after a procession through lower Manhattan, the cortege was ferried to Brooklyn and Green-Wood. In Martin Scorsese's movie *Gangs of New York*, Poole's character, given the name Bill Cutting, was played by Daniel Day-Lewis. The movie renewed interest in the case, and a new monument was built for Poole above the family vault.

Captain of the Green-Wood police and Civil War veteran Peter D. Lark, age 56, shot himself on the morning of March 16, 1899, in the cottage in which he lived on the cemetery grounds after several days of heavy drinking. He is believed to have been despondent over the death, a week earlier, of his mother and the fact that his second wife, of less than a year, had recently left him.

Seven

THE ARTS, SCIENCES, AND OTHER GENIUSES

This 19th-century print shows a fountain on Fountain Hill. Green-Wood was known for having several such waterworks. Note the period style of dress of the visitors. (Courtesy of the Green-Wood Historic Fund.)

FOUNTAIN AND RESERVOIR on Fountain Hill.

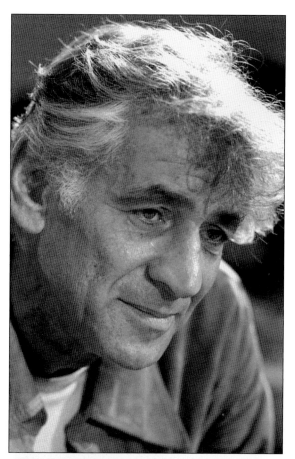

It is fitting that the beloved American composer and conductor who composed scores for many New York–themed shows and movies is buried in Green-Wood. *On the Waterfront*, which is set in Brooklyn, and *West Side Story*, set in Manhattan, are two of his most famous works. Leonard Bernstein's grave is said to be located on one of the highest elevation points in the cemetery, with a sublime view of Manhattan in the distance. Seen atop the grave of this great composer, who is buried with his wife, are tiny pebbles left as a sign of respect and remembrance as per Jewish custom. (Left, courtesy of the Library of Congress.)

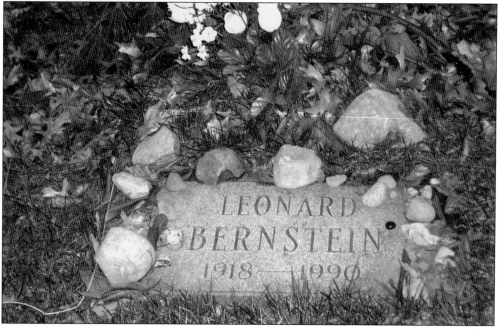

Artist Philip Evergood, who faced much adversity in his life, lies in an unmarked grave. Evergood, who created several works for the WPA in the 1930s, died in a house fire after accidentally setting his mattress ablaze while smoking in bed. This unfinished painting by Evergood was purchased by Green-Wood's president and adorns a wall in the executive offices.

What is perhaps one of the smallest stones in Green-Wood is that of James Kirke Paulding, novelist and U.S. secretary of the navy. A protégé of American author Washington Irving, Paulding is also known for penning the popular children's tongue twister "Peter Piper picked a peck of pickled peppers; Where is the peck of pickled peppers Peter Piper picked." Only his surname is inscribed on a flat marker, which is almost flush with the ground.

Famed opera singer, Emilio De Gogorza sang with the great Enrico Caruso, with whom he made some recordings. De Gogorza's wife, Emma Eames, shown with her husband in this photograph, was also an opera singer. When De Gogorza died in 1949, his funeral was held at the famed Frank E. Campbell the Funeral Chapel located on New York City's tony Madison Avenue. (Courtesy of the Library of Congress.)

Founder of the Christy's Minstrels, Edwin Christy used white singers in blackface to sing and act. His group became famous and toured the country singing such folk songs as "Old Susanna" and "Beautiful Dreamer." In 1862, Christy committed suicide by jumping out the window of his home in New York. (Courtesy of the Library of Congress.)

Dr. Abraham Jacobi, pictured here, was a key figure in the city's medical community and was the namesake for what became Jacobi Medical Center in the Bronx. Jacobi died in 1919. After a private service at his residence, New York City's most prominent physicians and surgeons came to pay their respects at the auditorium of the New York Academy of Medicine. Dr. Reginald H. Sayre, the vice president of the academy, told the audience, "A great light in the medical profession has gone out." Jacobi's wife, Mary, was also a doctor and the first professor of pediatrics in America. The couple lost three children in infancy, and the photograph below is of the memorial to the children, inscribed simply "the Babies." (Right, courtesy of the Library of Congress.)

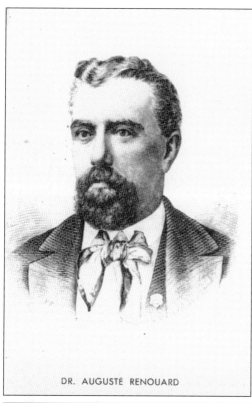

DR. AUGUSTÉ RENOUARD

Born on a Louisiana plantation in 1839, Auguste Renouard was educated as a medical doctor and later worked as a pharmacist and bookkeeper for an undertaking parlor. It was there that he became interested in the subject of arterial embalming, developing a method that gained wide acceptance in the United States. Writing often on the subject of embalming for *Casket*, a funeral trade publication, Renouard was soon considered an expert in the procedure. In 1878, Renouard published the first embalming textbook, *The Undertaker's Manual*. In 1895, Renouard founded the Renouard Training School for Embalmers in Manhattan. Considered by the funeral industry to be the foremost instructor in embalming, Renouard died in 1912. Etched upon his stately monument is "Erected by the Funeral Directors and Embalmers of the United States in Recognition of the Valuable Services of Auguste Renouard in Advancing the Science of the Preservation of the Dead. (Left, courtesy of the Edward C. and Gail R. Johnson family collection).

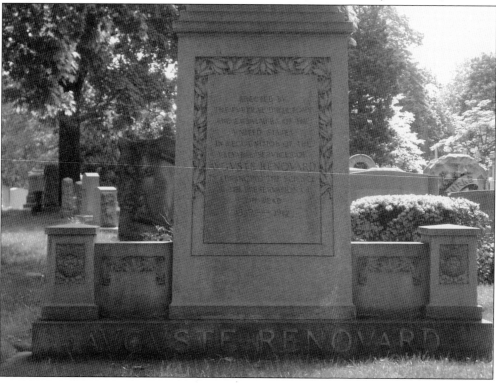

In 1835, James Gordon Bennett Sr. founded the *New York Herald* newspaper. By the time he turned over the running of the company to his son, James Jr., the *New York Herald* was said to have the highest circulation of any newspaper in America. When Bennett died in 1872, his home overflowed with mourners for his Catholic funeral service. Members of the press, including Horace Greeley, as well as politicians and businessmen all came to pay respects. Bennett's body rested temporarily in the Jerome mausoleum at Green-Wood, while his vault was being completed. (Courtesy of the Green-Wood Historic Fund.)

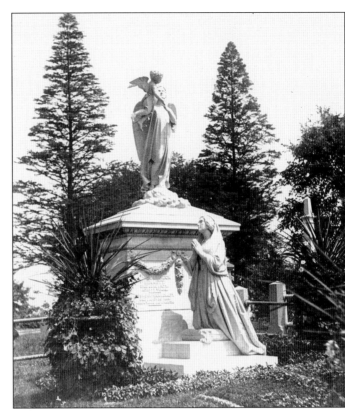

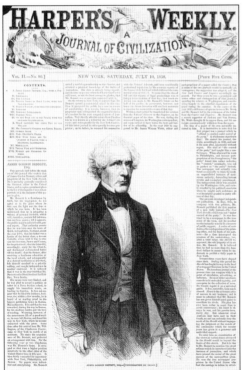

This front page from an 1858 edition of *Harper's Weekly* contains a biographical sketch of Bennett, with a portrait that appears to have been inspired by a photograph taken by famed photographer Matthew Brady. The article commanded the entire front page of the publication, showing the eminence Bennett had as a man of letters in that period. (Courtesy of the Library of Congress.)

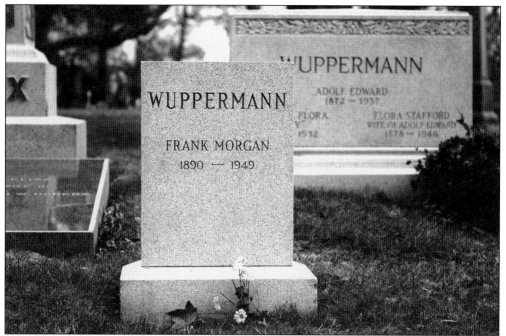

Actor Frank Morgan appeared in almost 100 films, but he will forever be remembered for his appearance in *The Wizard of Oz*, in which he played five roles, including the wizard. Morgan was honored, posthumously, with a star on Hollywood's Walk of Fame. His memorable line from the movie, "A heart is not judged by how much you love, but by how much you are loved by others," became one of his favorite quotes. His stone bears his birth name of Wuppermann.

Phoebe (pictured here) and Alice Cary were sisters and accomplished 19th-century poets who died within months of each other in 1871 and are buried together. Horace Greeley was an admirer of their work. At Alice's funeral, Greeley served as a pallbearer along with P. T. Barnum. Two years after Alice's death, Greeley began a memorial fund to erect a monument for the sisters. Only people who had known the sisters were asked to contribute. Among them were P. T. Barnum and the Harper brothers. A third sister, Elmina, is buried in the plot. (Courtesy of the Library of Congress.)

When Henry Jarvis Raymond, founder and editor of the *New York Times* until his death, died suddenly at the age of 49, accolades appeared in the country's major newspapers. Although suspicions were raised about the cause of Raymond's death, the official cause was listed as apoplexy. Rev. Henry Ward Beecher officiated at his 1869 funeral, after which Raymond's body was brought to Green-Wood for a private interment with only his family in attendance. (Courtesy of the Library of Congress.)

David Stone, editor of the *New York Journal of Commerce*, horticulturist, and one of the best-known men in Brooklyn, was known to be a workaholic. After his death, Stone's collection of plants was auctioned off. His will directed Green-Wood to use a portion of the $2,500 bequest to maintain his tomb and for keeping the large vases in front of the structure filled with flowers as a memorial to his wife. The vases have long since been removed.

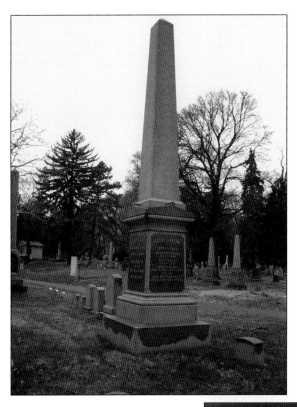

Dr. Cecil McCoy was a noted psychiatrist who testified as a "sanity expert" in a number of major New York trials. He was head of the state hospital for the insane in Binghamton and a visiting physician at Brooklyn's Kings County Hospital for 15 years. McCoy died in 1930.

Henry Rutgers was a prominent advocate of American independence from England and served in the Colonial army. He was a landholder with considerable wealth and made numerous donations to churches, schools, and charities. One of his most prominent donations endowed Queens College in New Brunswick, New Jersey, which later became Rutgers University. Rutgers died in 1830 and years later in 1865 his body was moved from a Manhattan churchyard to Green-Wood. For decades his grave marker did not bear his name. But in 2008, a stone with his name was placed. (Courtesy of Special Collections and University Archives, Rutgers University Libraries.)

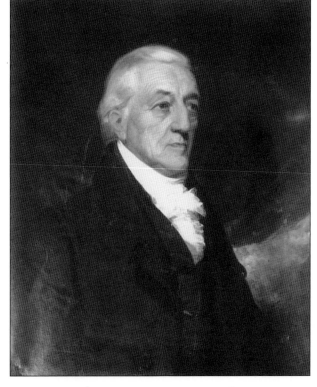

The famed inventor of the telegraph was actually an artist who studied at the Royal Academy in England. Samuel Finley Breese Morse was returning home from Europe by ship in 1832 in the midst of an art project when he met Charles Thomas Jackson, a Boston entrepreneur who was familiar with electromagnetism. Intrigued, Morse set aside his art project and developed the single wire telegraph. He partnered with Alfred Vail on what was to become known as the Morse code—sequences of short and long electrical pulses commonly known as dots and dashes to represent letters, numbers, and punctuation marks that make up a message. It would become the primary language of telegraphy in the world. Morse received a patent for the telegraph in 1847. Morse was a generous man who gave large sums to charity. Other people and corporations made millions using his inventions, yet most rarely paid him for the use of his patented telegraph. In 1836, Morse ran unsuccessfully for mayor of New York. (Right, courtesy of the Library of Congress; below, courtesy of the Green-Wood Historic Fund.)

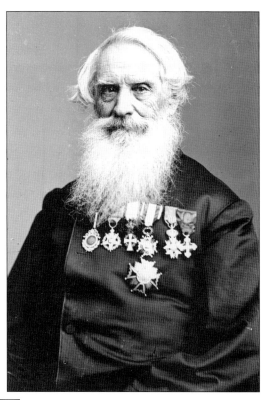

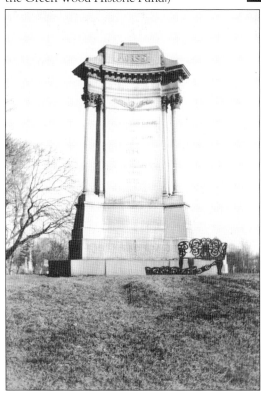

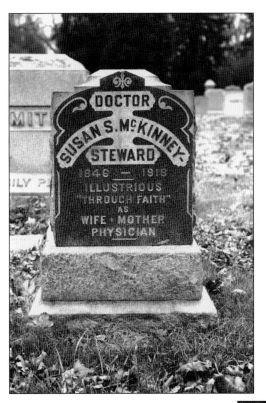

Born Susan Maria Smith, in Brooklyn, Dr. Susan S. McKinney-Steward was the first African American woman in New York to earn a medical degree and was a resident of Weeksville, Brooklyn's first African American community, which still exists today. As a child, McKinney-Steward played the organ in her church. She studied music with John Zundel, organist of the Plymouth Church of the Pilgrims. After graduating medical school, as valedictorian of her class, McKinney specialized in pediatrics in Brooklyn. A woman of faith, McKinney-Steward was married to two preachers. The Susan B. Smith McKinney Medical Society, formed by a group of African American women doctors, is named for her.

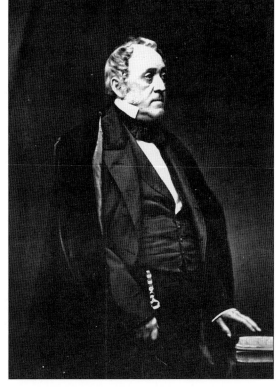

Dr. Valentine Mott, pictured here, was considered one of greatest surgeons of his time. He died in April 1865 after receiving the news that Pres. Abraham Lincoln had been shot. His son and namesake also became a doctor and developed a close association with Louis Pasteur of France. As a result, Pasteur permitted Mott to bring back one of the first rabbits inoculated with the rabies virus. Mott introduced Pasteur's rabies treatment to the United States, where it flourished against the deadly disease. The younger Mott died in June 1918 of a heart attack in his Manhattan home. (Courtesy of the Library of Congress.)

By the time of his death in 1930, inventor Elmer Sperry held more than 400 patents. Perhaps his biggest invention was the gyroscope, a device that stabilizes aircraft, ocean liners, and rockets. In 1910, Sperry founded the Sperry Gyroscope Company in Brooklyn. Sperry's funeral service was held at Brooklyn's Plymouth Congregational Church. During the service, airplanes passed overhead as a sign of respect. The clergyman who officiated referred to Sperry's 400 patents as reading "like a romance." (Right, courtesy of the Library of Congress; below, courtesy of the Green-Wood Historic Fund.)

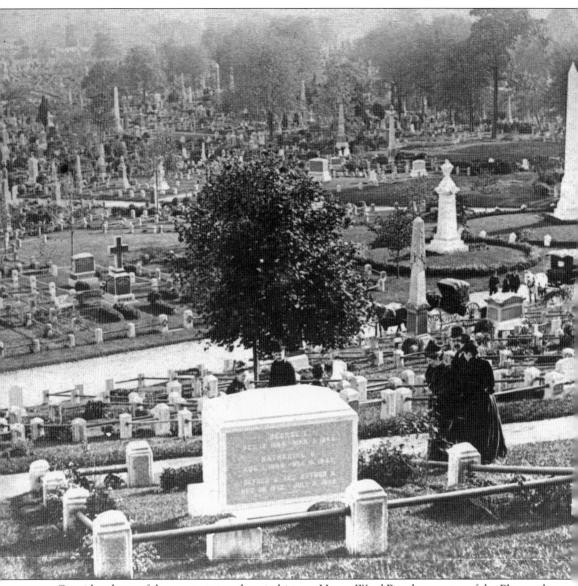

Considered one of the greatest preachers in history, Henry Ward Beecher, pastor of the Plymouth Church of the Pilgrims in Brooklyn, was an ardent abolitionist. His eloquence was so great that thousands attended his services, even Pres. Abraham Lincoln. Yet, when Beecher died in 1887, his funeral was not elaborate. The church service began an hour earlier than announced to throw off the hordes of reporters and the curious. Afterward 12 carriages carrying family, friends, and members of the church made their way to Green-Wood for Beecher's interment. An inscription on his burial monument reads, "He thinketh no evil." Beecher's sister Harriet Beecher Stowe was the author of *Uncle Tom's Cabin*. (Courtesy of the Green-Wood Historic Fund.)

Eight

GREEN-WOOD TODAY AND BEYOND

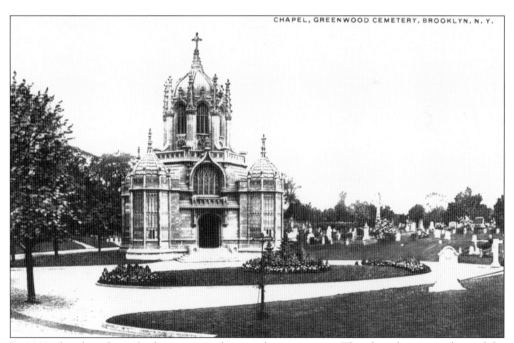

CHAPEL, GREENWOOD CEMETERY, BROOKLYN, N.Y.

In 1911, the chapel was built in a spot close to the main gate. The chapel is not only used for funeral services but also serves as the site of many of the cultural events for which Green-Wood has become known. It is also open on a daily basis for private prayer and meditation. This vintage postcard shows the chapel soon after its completion. (Courtesy of the Green-Wood Historic Fund.)

Green-Wood's crematory was constructed in 1954, and the first cremation took place a year later. The facility was built in response to the beginning of a growing trend in the funeral business for cremation as an alternative to burial. Among the famous people cremated at Green-Wood were jazz musician Eubie Blake; one of America's most esteemed journalists, Edward R. Murrow; mobster Vincent Gigante; civil rights activist James Weldon Johnson; musician Woody Guthrie; author John Steinbeck; and movie producer Bruce Paltrow.

This photograph shows an interior view of the Atrium Room in Green-Wood's crematory, renovated in 1998. In the background are columbarium walls holding urns with cremated bodies.

In 2006, Tranquility Garden was opened containing 8,066 niche spaces, in which cremated bodies are kept. Unique features include reflective panels, a koi pond, and the ability to view urns in their glass enclosures.

As with many cemeteries, Green-Wood has given families the option of aboveground burial in community crypts. Shown above is Crest-View Mausoleum. Another larger mausoleum is named Hillside.

Some of the most popular events to be held in the chapel are Green-Wood's ongoing literary events, which include author discussions and book signings. Depicted above is author Chester Burger (seated) autographing a copy of his book *Unexpected New York*. On the left is his publisher Jerry Goodwin. Other writers have also penned books about people buried at Green-Wood. Also shown on this page is Pulitzer Prize–winning author Debby Applegate, author of a book on Henry Ward Beecher titled *The Most Famous Man in America: The Biography of Henry Ward Beecher*. She is giving a talk by the grave of Elizabeth Tilton, who figures prominently in Beecher's story. (Above, courtesy of Jeffrey I. Richman; below, courtesy of Debby Applegate.)

Brooklyn borough president Marty Markowitz addresses children from PS 230 in Brooklyn in front of the Charles Feltman mausoleum. In 2005, the Green-Wood Historic Fund was given a grant from the History Channel to implement programs designed to foster schoolchildren's awareness of history. Green-Wood is dedicated to bringing the history of New York City to the local public schools. (Courtesy of Stacy Pisano.)

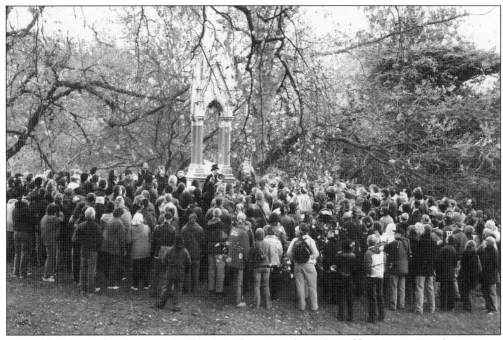

Green-Wood's resident historian Jeffrey I. Richman, author of *Brooklyn's Green-Wood Cemetery: New York's Buried Treasure*, leads a tour group on a recent Halloween tour, one of the most popular programs at the cemetery. In the photograph below, Richman is leading a group in a tour of the Civil War graves. (Courtesy of Jeffrey I. Richman.)

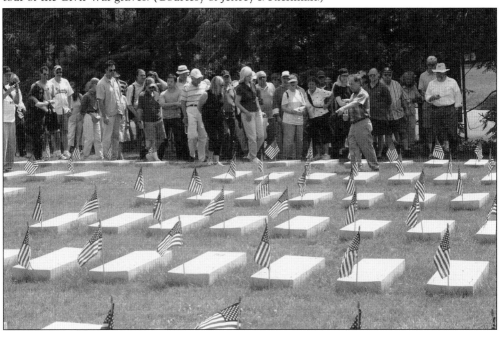

This photograph is of the 2007 Memorial Day reenactment, which commemorated the cemetery's Civil War Project. The event drew descendants of Civil War veterans from far and wide.

In July 2007, Benjamin Feldman, author of the book *Butchery on Bond Street*, leads a tour to the grave site of murdered dentist Dr. Harvey Burdell. (Courtesy of Jeffrey I. Richman.)

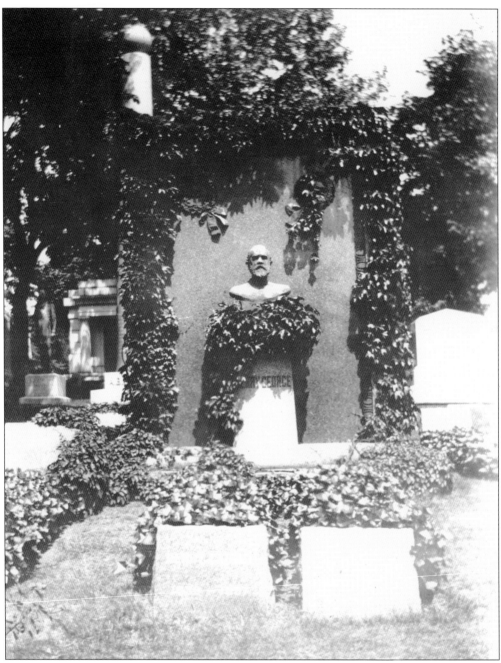

The Green-Wood Historic Fund was created in 1999 to garner contributions to support a wide variety of programs. Money raised is used to maintain Green-Wood's monuments, as well as to preserve its parkland. One of the monuments slated for restoration was that of economist Henry George, who requested nothing "funereal" at his 1897 funeral. The fund also supports public education programs aimed at advancing public knowledge about Green-Wood. (Courtesy of the Green-Wood Historic Fund.)

BIBLIOGRAPHY

Culbertson, Judi, and Tom Randall. *Permanent New Yorkers: A Geographical Guide to the Cemeteries of New York*. Chelsea, VT: Chelsea Green Publishing Company, 1987.

Green-Wood Cemetery. *Green-Wood: A Handbook*. Brooklyn: Self-published, 1973.

Jackson, Kenneth T., ed. *The Encyclopedia of New York City*. New Haven, CT: Yale University Press, 1993.

Marion, John Francis. *Famous and Curious Cemeteries: A Pictorial, Historical, and Anecdotal View of American and European Cemeteries and the Famous and Infamous People Who Are Buried There*. New York: Crown Publishers, Inc., 1977.

Richman, Jeffrey I. *Brooklyn's Green-Wood Cemetery: New York's Buried Treasure*. Brooklyn: Green-Wood Cemetery, 1998.

Robbins, Michael W., and Wendy Palitz. *Brooklyn: A State of Mind*. New York: Workman Publishing, 2001.

Schecter, Harold. *The Devil's Gentleman: Privilege, Poison and the Trial That Ushered in the Twentieth Century*. New York: Ballantine Books, 2007.

www.books.google.com

www.brooklynhistory.com

www.brooklynpubliclibrary.org

www.civilwar.com

www.findagrave.com

www.green-wood.com

www.history.com

www.loc.gov

www.nyhistory.org

Across America, People are Discovering Something Wonderful. *Their Heritage.*

Arcadia Publishing is the leading local history publisher in the United States. With more than 3,000 titles in print and hundreds of new titles released every year, Arcadia has extensive specialized experience chronicling the history of communities and celebrating America's hidden stories, bringing to life the people, places, and events from the past. To discover the history of other communities across the nation, please visit:

www.arcadiapublishing.com

Customized search tools allow you to find regional history books about the town where you grew up, the cities where your friends and family live, the town where your parents met, or even that retirement spot you've been dreaming about.